Toby Kamps

Steve Seid

with a contribution by

Jenni Sorkin

The Menil Collection
Houston

University of California
Berkeley Art Museum and Pacific Film Archive

Distributed by Yale University Press
New Haven and London

SILENCE

Published in conjunction with the exhibition *Silence*
Organized by The Menil Collection, Houston, and the University of California,
Berkeley Art Museum and Pacific Film Archive
Curated by Toby Kamps

This exhibition is generously supported by Louisa Stude Sarofim, Fayez Sarofim, The Andy Warhol
Foundation for the Visual Arts, Leslie and Shannon Sasser, Nina and Michael Zilkha, L&M Arts,
Paul and Janet Hobby, Ann and Henry Hamman, Lea Weingarten, proceeds from Men of Menil,
and the City of Houston.

The Menil Collection, Houston
July 27–October 21, 2012

University of California, Berkeley Art Museum and Pacific Film Archive
January 30–April 21, 2013

Published by
Menil Foundation, Inc.
1511 Branard Street
Houston, Texas 77006
and
UC Berkeley Art Museum and Pacific Film Archive
2625 Durant Avenue
Berkeley, CA 94720

Distributed by Yale University Press
P.O. Box 209040
302 Temple Street
New Haven, Connecticut 06520-9040
www.yalebooks.com/art

ISBN: 978-0-300-17964-4
CIP data appear at the end of the book

Endsheets: front, details of Theresa Hak Kyung Cha, *Mouth to Mouth*, 1975 (see p. 18);
back, details of Marcel Broodthaers, *Speakers Corner*, 1972 (see p. 15)

CONTENTS

FOREWORD

Silence looks at nearly a century of modern and contemporary art investigating the subject as theme and material. The exhibition brings together a selection of works by four generations of international artists to ask—perhaps more than to answer—questions such as: What is silence? Why does it have such a grip on the imagination? And why do we automatically connect it to important parts of the world such as mystery, memory, contemplation, and mourning? Silence, this exhibition demonstrates, is a means for avant-garde art both to reach into new aesthetic territory and to discover even more ways of communicating and expressing one of art's perennial functions—to give form to the intangible.

This exhibition and catalogue project comes at an especially noisy moment, as the din of digital life increasingly hollows out silence and any attendant powers of concentration. The visitor experience at the Menil Collection—a neighborhood of art that includes the Cy Twombly Gallery, the Dan Flavin installation at Richmond Hall, and, integral to the gestalt, the Rothko Chapel, a world-renowned ecumenical space for quiet meditation and prayer—offers a rare alternative to the aural clutter of everyday life. The campus cultivates an environment low in audible and visual noise to honor the vision of museum cofounders John and Dominique de Menil, which she articulated at the museum's inception by writing that "perhaps only silence and love do justice to a great work of art." The city of Berkeley and the UC campus, home to the Free Speech Movement, are not known for silence of any kind. Nevertheless, in its galleries and theater, the University of California, Berkeley Art Museum and Pacific Film Archive presents works of art that often take their audiences to a place of deep concentration and inwardness. The visual art collection has many works sympathetic to the concerns of *Silence*, and the extensive film and video archive houses numerous examples in which one can explore the complex relationships of moving images, sound, and silence.

It is fitting that this exhibition was conceived and initiated as his first for the Menil by Curator of Modern and Contemporary Art Toby Kamps. He was joined by Steve Seid, Video Curator at the University of California, Berkeley Art Museum and Pacific Film Archive, the curator of a three-part program exploring silence and the absence of sound in film and video.

As project co-organizers, we are grateful to the participating artists, many of whom have lent works from their own studios. The collectors and institutions who have lent to the exhibition also deserve special thanks, for without their generosity the exhibition would not be possible. They are listed in the curators' acknowledgments that follow. And we are deeply appreciative of the hard work of all our colleagues in Houston and Berkeley involved in the organization of this project.

Finally, we wish to acknowledge the commitment of our funders. This project is generously supported by Louisa Stude Sarofim, Fayez Sarofim, The Andy Warhol Foundation for the Visual Arts, Leslie and Shannon Sasser, Nina and Michael Zilkha, L&M Arts, Paul and Janet Hobby, Ann and Henry Hamman, Lea Weingarten, proceeds from Men of Menil, and the City of Houston.

Josef Helfenstein
Director
The Menil Collection

Lawrence Rinder
Director
University of California, Berkeley Art Museum and
Pacific Film Archive

ACKNOWLEDGMENTS

Although this exhibition investigates the idea of silence, it would not have been possible without countless spirited conversations with artists, collectors, patrons, and museum and gallery peers. First, for their extraordinary generosity and support, I want to thank the lenders to the exhibition in Houston and Berkeley: Timothy Baum; Galerie Diana Stigter, Amsterdam; Galerie Jan Mot, Brussels; Galleri Nicolai Wallner, Copenhagen; Hessel Museum of Art, Annandale-on-Hudson, New York; Los Angeles County Museum of Art; Marian Goodman Gallery, New York; Sybil and Matthew Orr; Elliot and Kimberly Perry; P.P.O.W. Gallery, New York; The Rachofsky Collection, Dallas; The Robert Rauschenberg Foundation, New York; Sean Kelly Gallery, New York; Seattle Art Museum; Susan Sosnick; Susanne Vielmetter Los Angeles Projects; Tate and National Galleries of Scotland; Geoff Tuck and David Richards; University of California, Berkeley Art Museum and Pacific Film Archive; Walker Art Center, Minneapolis; Migs and Bing Wright, New York; Zeno X Gallery, Antwerp; and several private collectors who wish to remain anonymous.

Of course, all the artists in the exhibition—living and deceased—deserve recognition, but those with whom I've discussed the project deserve special thanks for their generosity and enthusiasm. Manon de Boer, Michael Elmgreen and Ingar Dragset, Jennie C. Jones, Jacob Kirkegaard, Mark Manders, Christian Marclay, Kurt Mueller, Bruce Nauman, Amalia Pica, Steve Roden, Tino Sehgal, and Stephen Vitiello—without you, *Silence* would not have been possible.

My colleague Video Curator Steve Seid did an outstanding job organizing three film and video programs that complement the visual art in *Silence*. Among others at our co-organizing partner, the UC Berkeley Art Museum and Pacific Film Archive, I wish to thank Director Lawrence Rinder and Chief Curator and Director of Programs and Collections Lucinda Barnes for their belief in this project. Director of Foundation and Corporate Relations Elisa Isaacson and her development team were inspired partners in finding support for this project. Our collaboration will surely serve as a model for future joint endeavors.

I also am grateful for the help and facilitation of many terrific, far-flung peers: Darcy Alexander, Chief Curator, Walker Art Center; Anthony Allen, Associate Director, Paula Cooper Gallery, New York; Lucy Askew, former Managing Curator, ARTIST ROOMS, Tate and National Galleries of Scotland; Karina Daskalov, Director, Marian Goodman Gallery, New York; Carol Eliel, Curator of Modern Art, Los Angeles County Museum of Art; Jacob Fishman, Lightwriters Neon, Inc.; Maria Gilissen, Estate of Marcel Broodthaers; Laura Kuhn, Director, John Cage Foundation; Juliet Myers, Manager, Bruce Nauman studio; Marisa C. Sánchez, Associate Curator of Modern and Contemporary Art, Seattle Art Museum; Franklin Sirmans, Terri and Michael Smooke Department Head and Curator of Contemporary Art, Los Angeles County Museum of Art; and David White, Curator, The Robert Rauschenberg Foundation, New York.

A special debt of gratitude is owed to Menil Collection Director Josef Helfenstein for his commitment to this ambitious exhibition. Additionally, all members of the museum's Board of Trustees, in particular President Harry C. Pinson and Chairman Louisa Stude Sarofim, have been strong supporters of this project. Their love for the museum is matched by the dedication of its staff. I am indebted to the inspired efforts of my talented colleagues in the Curatorial Department: former Curator for Collections and Research Kristina Van Dyke, Chief Curator Emerita Bernice Rose, Curator Michelle White, Assistant Curator Clare Elliott, Manager of Curatorial Projects Melanie Crader, and Administrative Assistant Tessa Ferreyros. Collections Registrar Mary Kadish was, as usual, an especially valuable resource. Many thanks go to Rice University Fellow Katia Zavistovski for her formidable research and organizational skills, as well as for her contribution of artist biographies to the catalogue.

I would like to thank the staff of the Menil for their expert help in realizing this exhibition. It has been a pleasure to work with all of them, and I appreciate their consideration and guidance as I pulled together my first major project at the Menil. Thanks to Head Librarian Eric Wolf, Catalogue Librarian Rita Marsales, and Archivist Geraldine Aramanda for their invaluable research support. Exhibitions Designer Brooke Stroud and Exhibition Design Assistant Kent Dorn developed a thoughtful and elegant gallery layout for a wide range of works. The skill and expertise of Head of Art Services Thomas Walsh and Preparators Tobin Becker and Tony Rubio has been invaluable. Associate Registrar Judy Kwon and Chief Registrar Anne Adams ably coordinated the exhibition's complex logistics. Facilities and Security Manager Steve McConathy and his staff, including Gallery Attendant Supervisor Getachew Mengesha and Facilities Engineer Tim Ware, ensured the works' safety while on the premises. Special thanks go to Chief Conservator Brad Epley and his staff for caring for the varied works in the exhibition. And special appreciation for their hard work goes to the Development Department: Director of Advancement Aline Wilson and her staff, including Development Director Peter Hyland, Manager of Special Events Elsian Cozens, Manager of Membership Programs Amanda Shagrin, Senior Development Associate, Stewardship and Special Projects, Nancy Kate Prescott, and Membership Coordinator Jennifer Hennessy. Thanks also to former Chief Financial Officer Tom Madonna, Manager of Finance Susan Epley, and the business office team for their superb administrative oversight. Much gratitude for the inspired creative programming goes to Director of Public Programs Karl Kilian and Program Coordinator Anthony Martinez; to Director of Communications Vance Muse and Communications Assistant Gretchen Bock Sammons for getting the word out; and for the steady support of Barbara Grifno and Ebony McFarland in the director's office.

Special thanks also to Director of Publishing Joseph N. Newland and to Assistant Editor Sarah E. Robinson, who ably oversaw the development and production of this catalogue, and for the invaluable help of Rights and Reproductions Manager Erh-Chun Amy Chien. I also am grateful to Rita Jules of Miko McGinty Inc. for her inspired and original catalogue design.

It was a pleasure and an honor to work with my colleagues and contributors to this catalogue. Jenni Sorkin, Assistant Professor of Contemporary Art and Critical Studies at the University of Houston, and Steve Seid, Video Curator at the UC Berkeley Art Musem and Pacific Film Archive, contributed illuminating and fresh essays.

In addition, I would like to thank a number of individuals for their important contributions to the exhibition and its final shape: Surpik Angelini and the Transart Foundation for Art and Anthropology (thanks for sharing this great, big idea), Tedd Bale, Ted Bonin, Marie-Puck Broodthaers, Pavel Buchler, Luca Buvoli, James Clifton, Jillian Conrad, Renée Coppola, Leo Costello, Christoph Cox, Jade Dellinger, David Dove, Michael Galbreth, Alison de Lima Greene, Deborah Hay, Robin Held, Matthew Higgs, Rodney Hill, Gordon Hughes, Diana Hunnewinkel, Fredericka Hunter, Nina Katchadourian, Irwin and Barbara Kremen, Chris Kubick, Laura Kuhn, David Little, Kris Martin, Jack Massing, Will Michels, Robert Mnuchin, Paula Newton, Damir Ocko, Anette Østerby, Richard Patterson, George Prochnik, Christina Rees, Anne J. Regen, Dont Rhine, Sarah Rothenberg, Jenny Schlenzka, Allan Schwartzman, Philippe Siauve, Franklin Sirmans, George Slade, Damon Smith, Jenni Sorkin, Lois Stark, Mungo Thomson, Nestor Topchy, Max Underwood, Hamza Walker, Jack Wendler, Lawrence Weschler, Emilee Dawn Whitehurst, Charlie Wylie, and Nurit Zuker. For their generous ideas, suggestions, and inspirations, I am truly grateful.

Toby Kamps
Curator of Modern and Contemporary Art
The Menil Collection

We wish to thank the following for their indispensable help: Dominic Angerame, Canyon Cinema, San Francisco; Jacob Barreras and Don Yannacito, University of Colorado, Boulder, Film Department; Rebecca Cleman, Electronic Arts Intermix, New York; John Hanhardt, Smithsonian American Art Museum, Washington, DC; Andrew Lampert, Anthology Film Archives, New York; Abina Manning, Video Data Bank, Chicago; Anne Morra, The Museum of Modern Art, New York; Jon Shibata, UC Berkeley Art Museum and Pacific Film Archive; Mark Toscano, Academy Film Archive, Los Angeles; and all the artists, particularly Nathaniel Dorsky, Steve Roden, and Stephen Vitiello.

Steve Seid
Video Curator
University of California, Berkeley Art Museum and
Pacific Film Archive

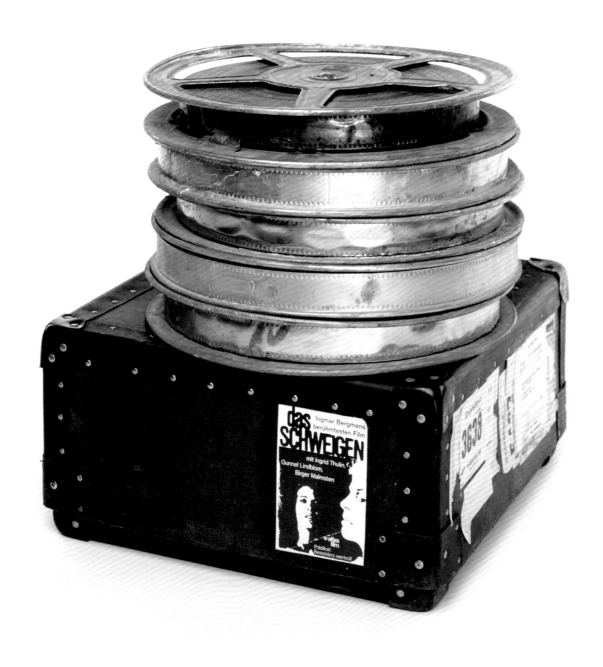

Joseph Beuys, *Das Schweigen (The Silence)*, 1973
5 reels of 35mm film varnished and galvanized in copper and zinc
Height: 15 inches (38.1 cm), reels: 7½ inches diam. (19.1 cm diam.)
Collection Walker Art Center, Minneapolis, Alfred and Marie Greisinger Collection
Walker Art Center, T. B. Walker Acquisition Fund, 1992

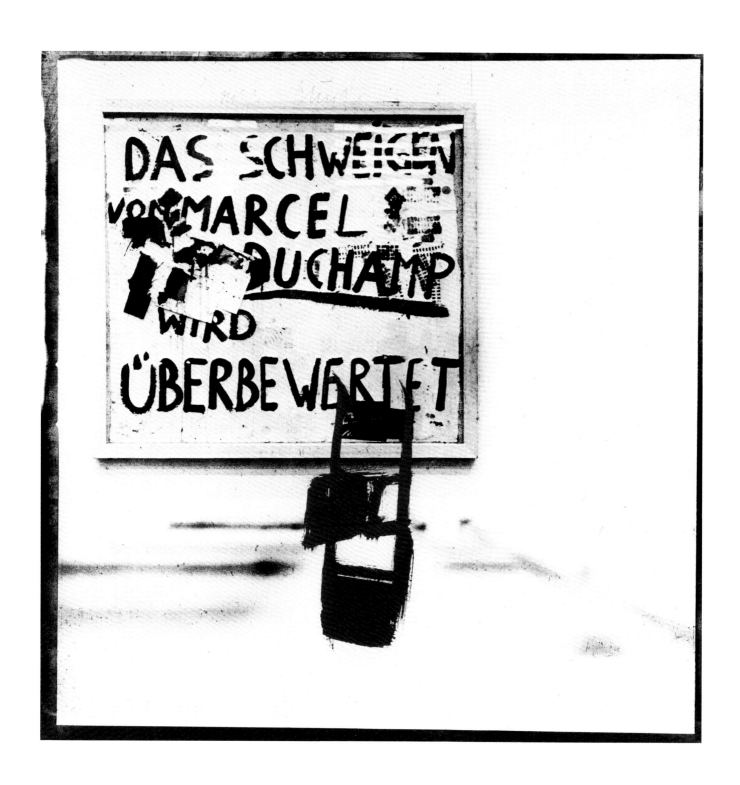

Joseph Beuys, *Das Schweigen von Marcel Duchamp wird überbewertet*
(The Silence of Marcel Duchamp Is Overrated), **c. 1973**

From the 3-Tonnen Edition. Oil on silkscreen on PVC. 18⅛ x 18⅛ inches (46 x 46 cm)
Private collection, Cologne. Courtesy of Galerie Holtmann, Cologne

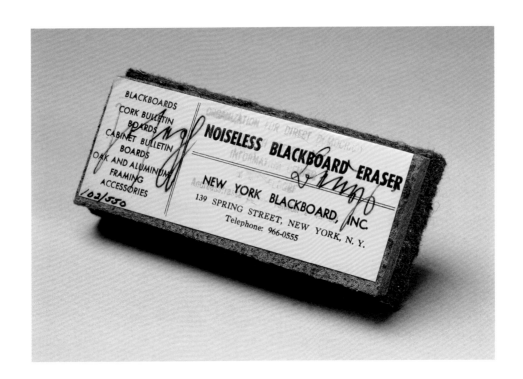

Joseph Beuys, *Noiseless Blackboard Eraser*, 1974

Felt eraser, offset lithograph on paper label, and ink stamp. 2 x 5⅛ x 1 inches (5.1 x 13 x 2.5 cm)
Collection Walker Art Center, Minneapolis, Alfred and Marie Greisinger Collection
Walker Art Center, T. B. Walker Acquisition Fund, 1992
(Image courtesy of Mildred Lane Kemper Art Museum, Washington University in St. Louis)

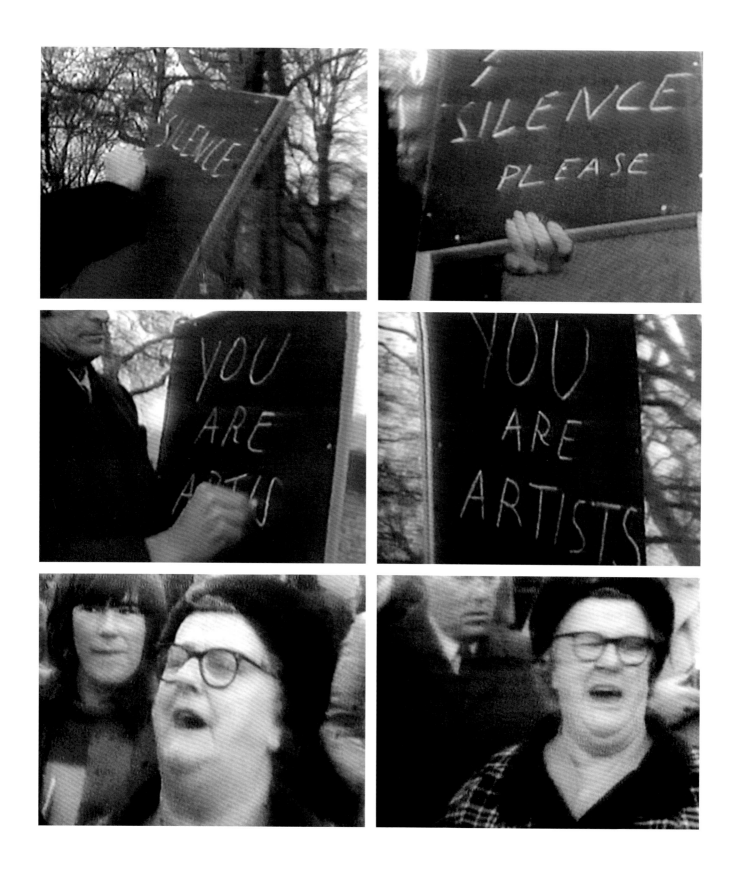

Marcel Broodthaers, *Speakers Corner*, 1972

16mm film transferred to DVD, black-and-white, sound, approx. 16 min. 30 sec.
Courtesy of Marian Goodman Gallery, New York and Paris

John Cage, Printed score for *4'33"*, 1953

Proportional notation version (details). Each page 11 x 8½ inches (27.9 x 21.6 cm)

I

TACET

II

TACET

III

TACET

John Cage, Printed score for _4'33"_, 1960

Tacet, tacet, tacet version. 11⅞ x 9⅛ inches (30.2 x 23.2 cm)

Theresa Hak Kyung Cha, *Mouth to Mouth*, 1975

Single-channel video, black-and-white, sound, 8 min.
University of California, Berkeley Art Museum and Pacific Film Archive
Gift of the Theresa Hak Kyung Cha Memorial Foundation

Manon de Boer, *Two Times 4'33",* **2008**

35mm film transferred to DVD, color, sound, 12 min. 30 sec.
Courtesy of Jan Mot, Brussels

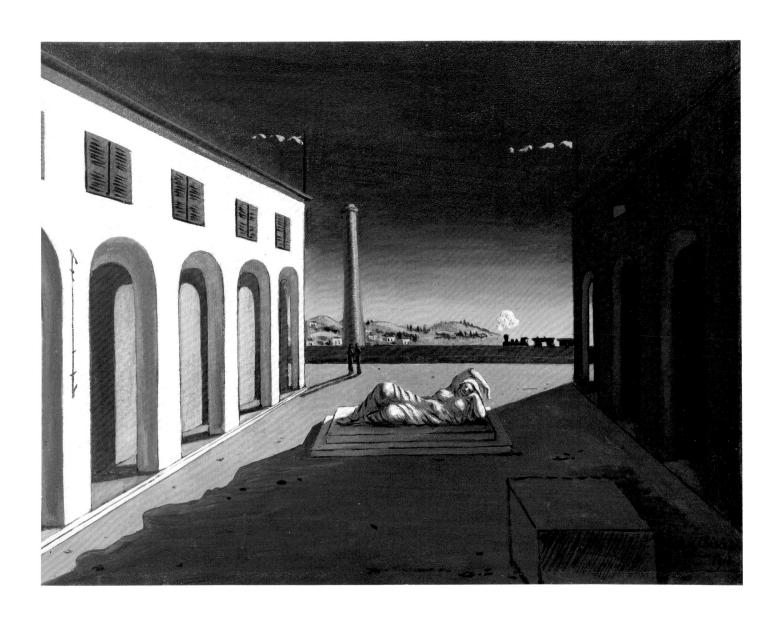

Giorgio de Chirico, *Melancholia*, **1916**

Oil on canvas. 20 x 26½ inches (51.1 x 67.3 cm)
The Menil Collection, Houston

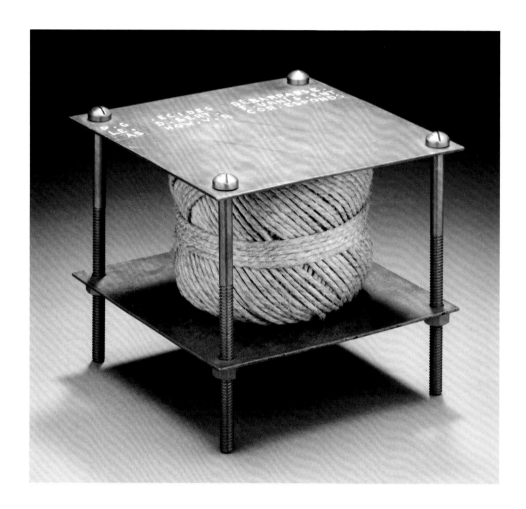

Marcel Duchamp, *With Hidden Noise* (1916), 1964 version

Ball of twine, brass plates, screws, and unknown object
4⅜ x 5⅛ x 5⅛ inches (11.1 x 13 x 13 cm)
Berkeley: Los Angeles County Museum of Art, Purchased with funds provided by The Broad Art Foundation,
Carla and Fred Sands, Christopher V. Walker, Suzanne and David Booth, Alice and Nahum Lainer, Herta and Paul Amir, Janet Dreisen,
Betty and Brack Duker, Judith and Steaven K. Jones, and Sandy and Jack Terner through the 2003 Collectors Committee
Houston: Collection of Timothy Baum, New York

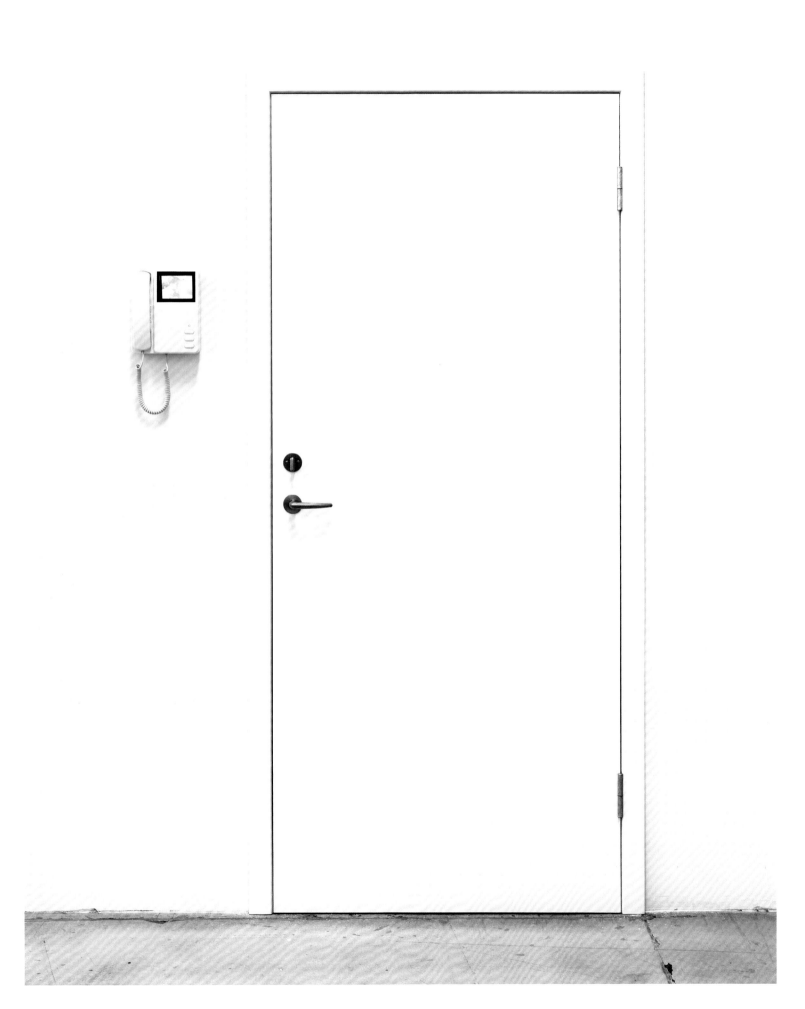

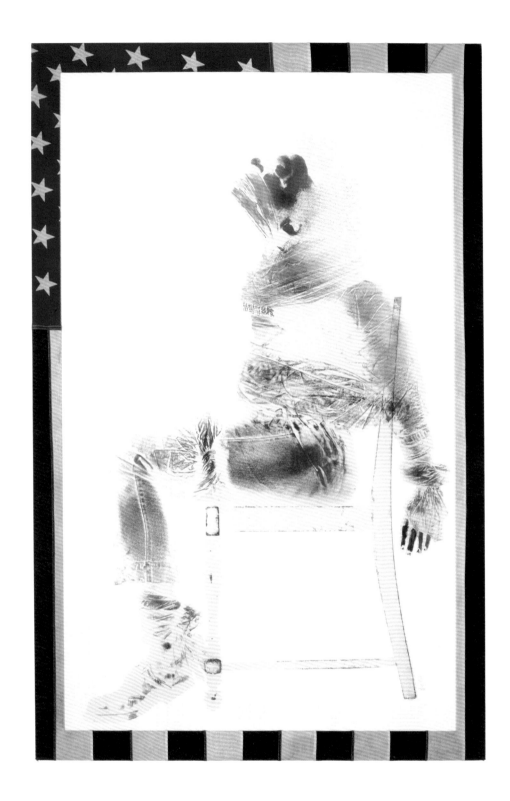

David Hammons, *Injustice Case*, 1970

Body print (margarine and powdered pigment) and American flag. 63 x 40½ inches (160 x 102.9 cm)
Los Angeles County Museum of Art, Museum Acquisition Fund (Houston only)

OPPOSITE: Michael Elmgreen & Ingar Dragset, *The Date*, 2009

Wood, paint, door handle, security chain, hinges, videophone, and transformer
Door: 85⅝ x 45⅛ x ¾ inches (217.5 x 114.5 x 2 cm), videophone: 8¾ x 3⅛ x 2⅜ inches (22 x 8 x 6 cm)
Courtesy of Galleri Nicolai Wallner, Copenhagen

September 30, 1978

STATEMENT

I, Sam Hsieh, plan to do a one year performance piece,
to begin on September 30, 1978.

I shall seal myself in my studio, in solitary confinement
inside a cell-room measuring 11'6" X 9' X 8'.

I shall NOT converse, read, write, listen to the radio or
watch television, until I unseal myself on September 29, 1979.

I shall have food every day.

My friend, Cheng Wei Kuong, will facilitate this piece by
taking charge of my food, clothing and refuse.

Sam Hsieh

Sam Hsieh

111 Hudson Street, 2nd/Fl. New York 10013

ROBERT PROJANSKY
ATTORNEY AT LAW
415 WEST BROADWAY
NEW YORK, NEW YORK 10012
(212) 925-0350

TO WHOM IT MAY CONCERN:

I HEREBY CERTIFY:

That on the 30th day of September, 1978, I did personally observe
Mr. SAM HSIEH enter a cell constructed of pine dowels and two-by-fours
and located in the second floor premises at 111 Hudson Street in the City,
County and State of New York; that I then and there did observe the door to
said cell locked immediately upon Mr. HSIEH's entry and each and every joint
of said cell sealed with a paper seal inscribed by me that day;

That on the 29th day of September, 1979, I did personally observe
Mr. SAM HSIEH within said cell and each and every paper seal inscribed by me
as aforesaid then and there still complete, intact and unbroken; and

That based upon said observations aforesaid, I hereby certify that
Mr. SAM HSIEH remained within said locked cell continuously for a period of
ONE YEAR from September 30, 1978, until the door thereof was opened for him
and he did exit from said cell on September 29, 1979.

IN WITNESS WHEREOF, I have hereunto set my hand and seal this 30th day
of September, 1979.

Robert Projansky [L.S.]

Tehching Hsieh, *One Year Performance 1978–1979*

Statement and witness statement. Paper. Each 11 x 8½ inches (27.9 x 21.6 cm)
Courtesy of the artist and Sean Kelly Gallery, New York

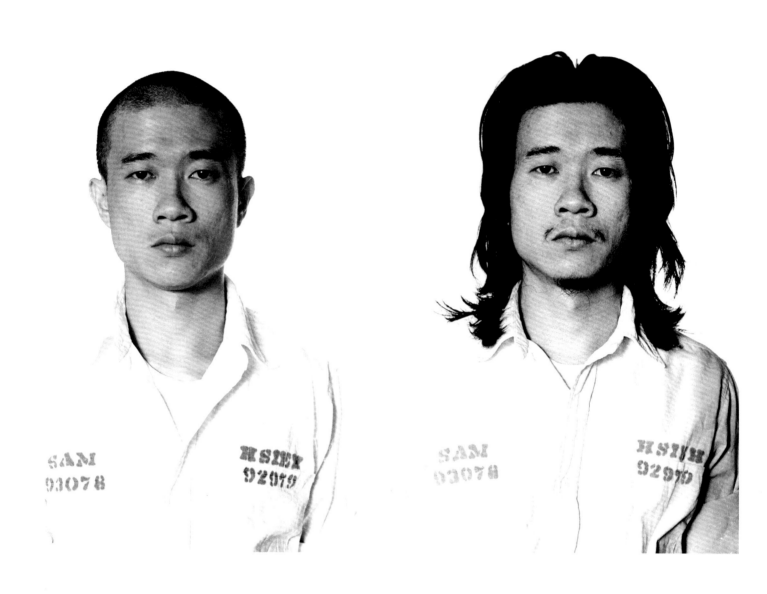

Tehching Hsieh, *One Year Performance 1978–1979*

365-Portrait, Day 1 and Day 365. Gelatin silver prints. Each 5⅝ x 4 inches (14.3 x 10.2 cm)
Courtesy of the artist and Sean Kelly Gallery, New York

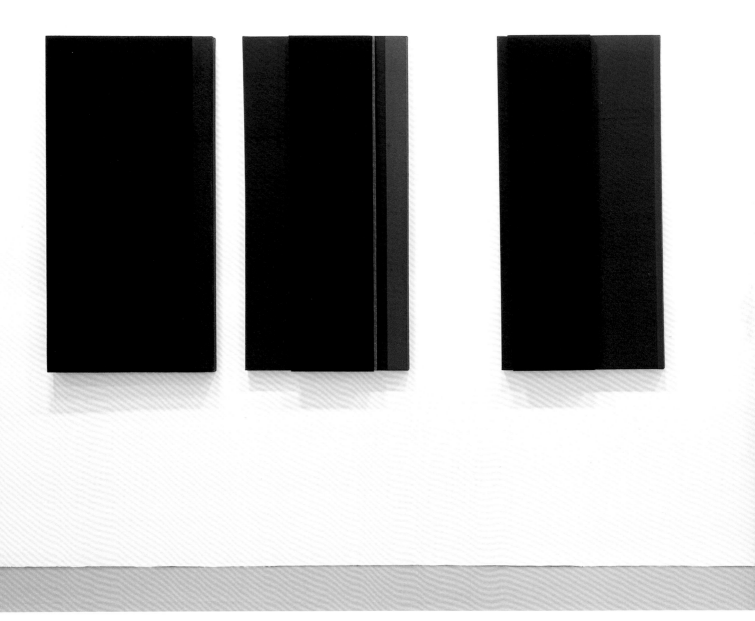

Jennie C. Jones, *Semitone-Bar*, *Resonance at 1/3*, and *Deep Tone*, all 2011

Acoustic absorber panel, gesso, and acrylic glaze on canvas
Acoustic absorber panel and acrylic on canvas
Acoustic absorber panel, gesso, and acrylic glaze on canvas
Each 48 x 24 x 3 inches (121.9 x 61 x 7.6 cm)
Collection of the artist

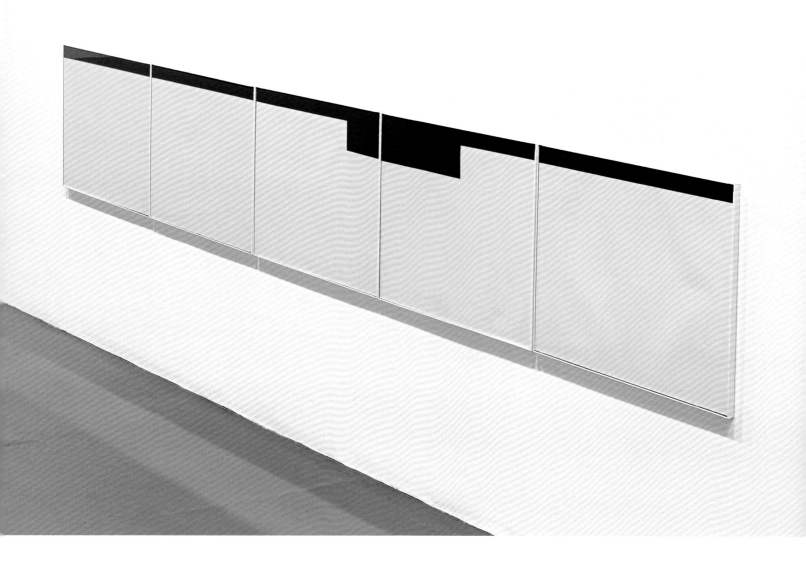

Jennie C. Jones, *Long, Low, Rest (semibreve)*, 2011

Acrylic on paper. 16 x 100 inches (40.6 x 254 cm)
Collection of Elliot and Kimberly Perry, Memphis

OPPOSITE: Jennie C. Jones, *Sustained Black with Broken Time and Undertone*, 2011

Acoustic absorber panel and acrylic on canvas
Square: 24 x 24 x 2 inches (61 x 61 x 5.1 cm), rectangle: 12 x 48 x 2 inches (30.5 x 121.9 x 5.1 cm)
Collection of the artist

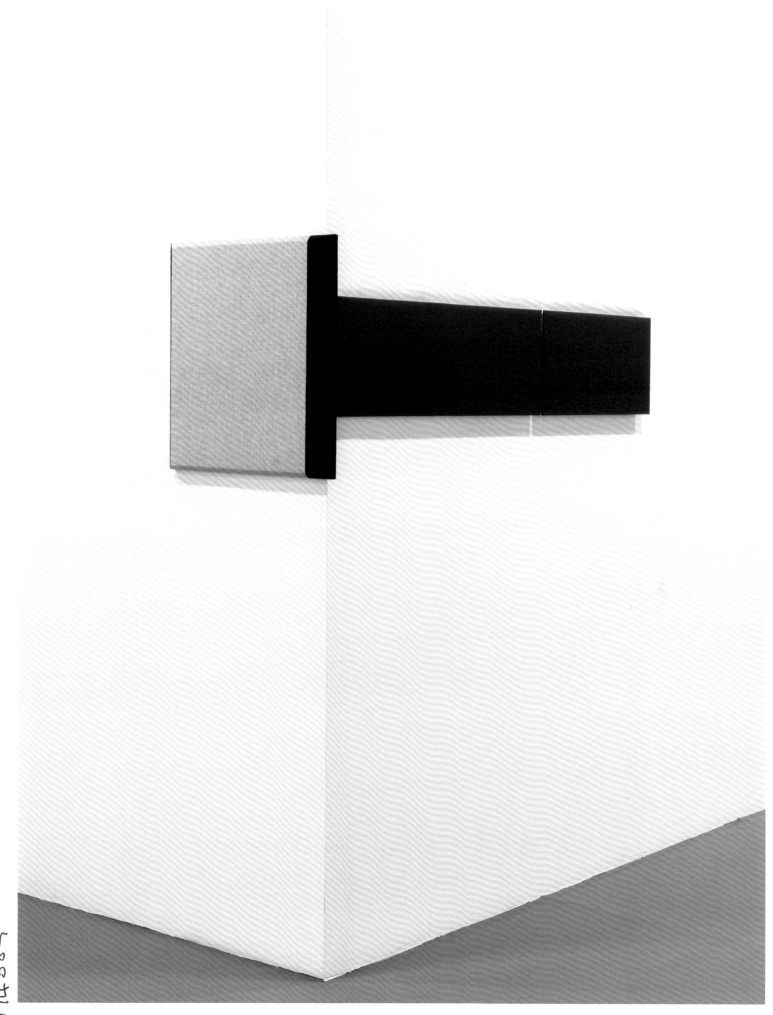

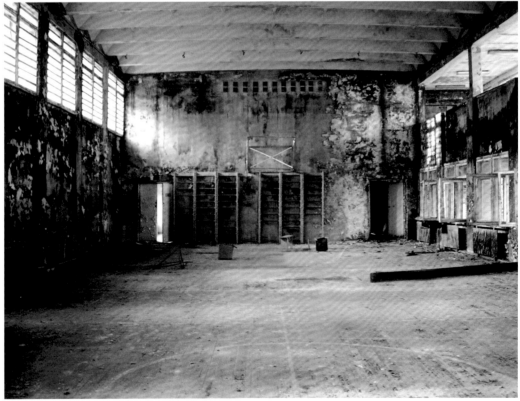

Jacob Kirkegaard, *AION*, 2006

DVD projection, color, sound, 50 min.
Courtesy of the artist

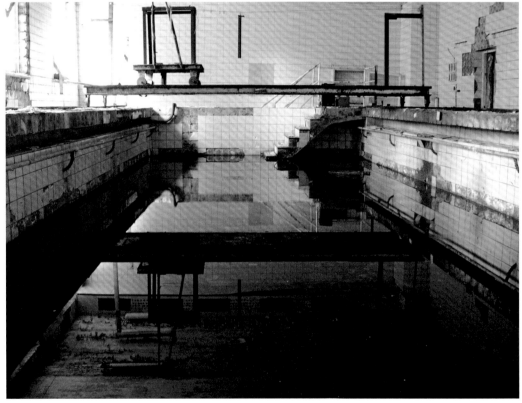

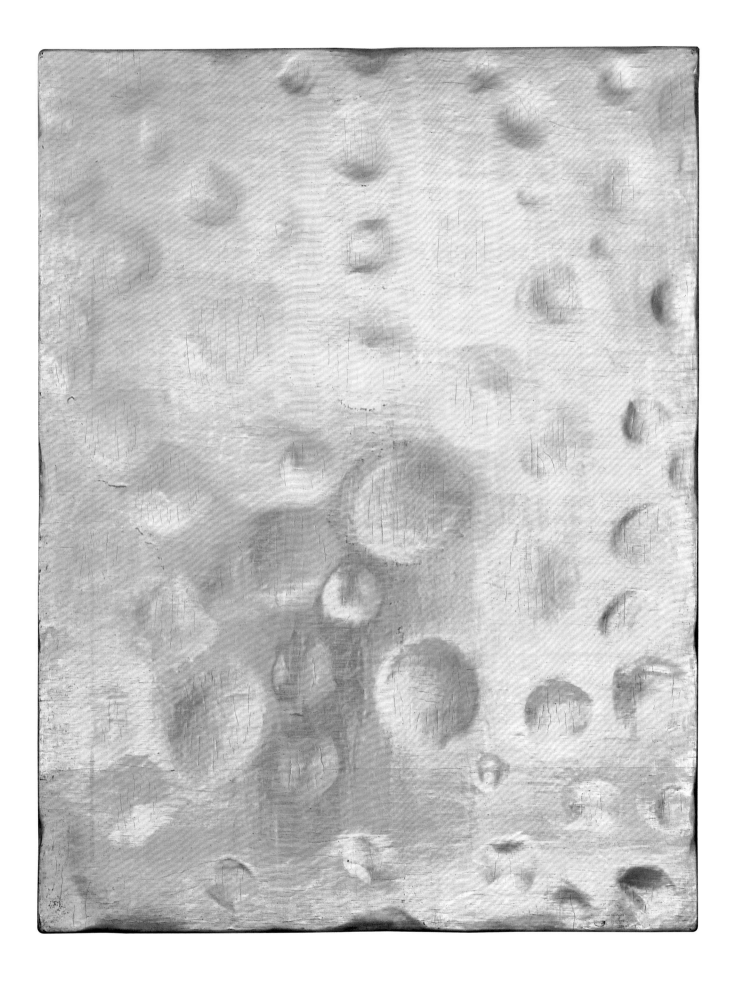

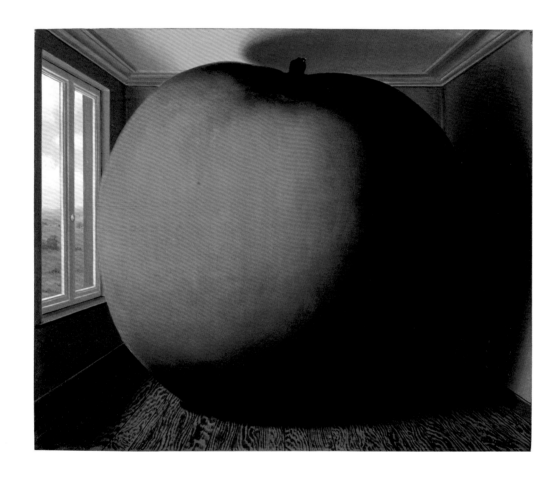

René Magritte, *La chambre d'écoute (The Listening Room)*, 1952

Oil on canvas. 17⅞ x 21¾ inches (45.2 x 55.2 cm)
The Menil Collection, Houston, Gift of Fariha Friedrich

OPPOSITE: Yves Klein, *Untitled (Monogold)*, c. 1960

Gold leaf on wood. 78½ x 60¼ x ¾ inches (199.4 x 153 x 2 cm)
The Menil Collection, Houston (Houston only)

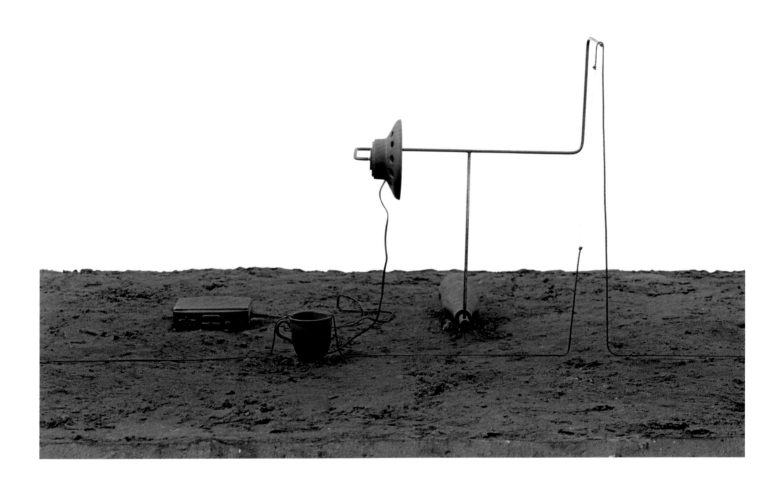

Mark Manders, *Reduced Summer Garden Night Scene (Reduced to 88%)*, **2011**

Sand, painted porcelain, iron, wood, and rope
approx. 33½ x 59⅜ x 39¾ inches (85 x 151 x 101 cm)
Courtesy of Zeno X Gallery, Antwerp, and Tanya Bonakdar Gallery, New York

OPPOSITE: Mark Manders, *Silent Head on Concrete Floor*, **2011**

Painted wood, epoxy, and canvas, offset print on paper, concrete, and wood
approx. 27⅝ x 23⅜ x 34¼ inches (70 x 59.4 x 87 cm)
Courtesy of Zeno X Gallery, Antwerp, and Tanya Bonakdar Gallery, New York

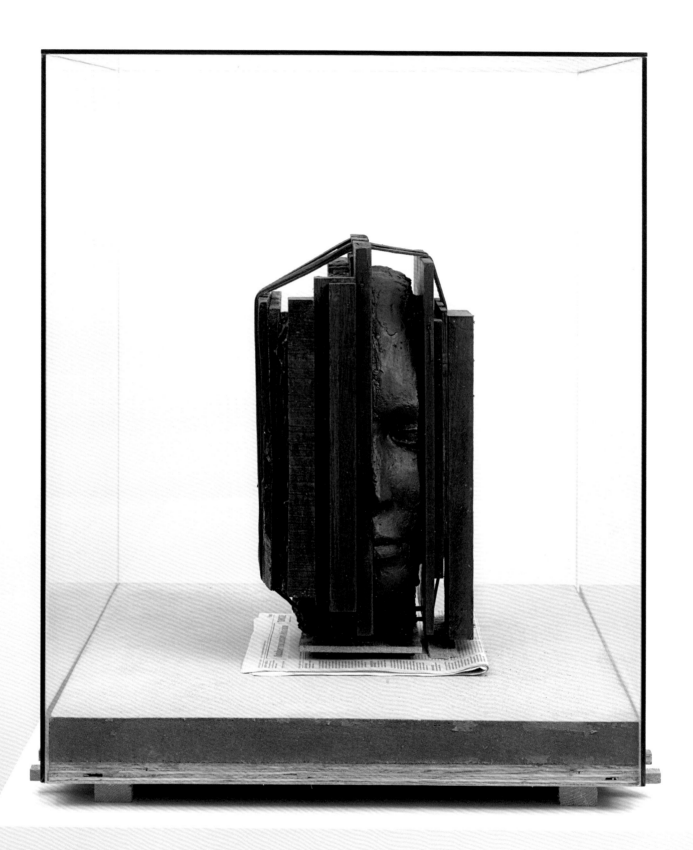

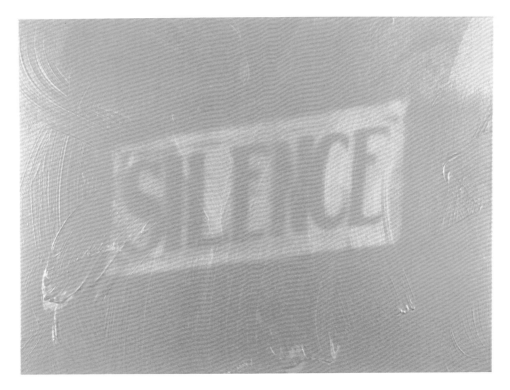

Christian Marclay, *Gold Silence (The Electric Chair)*, **2006**

Silkscreen ink on synthetic polymer paint on canvas. 22 x 30¼ inches (55.9 x 76.8 cm)
Marieluise Hessel Collection, Hessel Museum of Art, Center for Curatorial Studies
Bard College, Annandale-on-Hudson, New York

Christian Marclay, *Pink Silence (The Electric Chair)*, **2006**

Silkscreen ink on synthetic polymer paint on canvas. 22 x 30¼ inches (55.9 x 76.8 cm)
Collection of Migs and Bing Wright, New York

Christian Marclay, *Silver Silence (The Electric Chair)*, **2006**

Silkscreen ink on synthetic polymer paint on canvas. 22 x 30¼ inches (55.9 x 76.8 cm)
Private collection

Christian Marclay, *Yellow Silence (The Electric Chair)*, **2006**

Silkscreen ink on synthetic polymer paint on canvas. 22 x 30¼ inches (55.9 x 76.8 cm)
Collection of Sybil and Matthew Orr

Christian Marclay, *Grey Drip Door (The Electric Chair)*, **2006**

Silkscreen ink on synthetic polymer paint on canvas. 94⅜ x 51¼ inches (239.7 x 130.2 cm)
Private collection

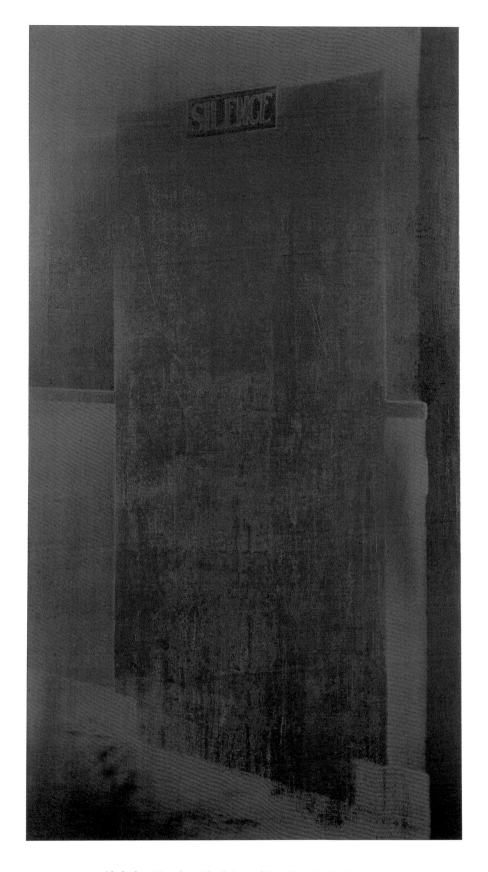

Christian Marclay, *Black Door (The Electric Chair)*, 2006

Silkscreen ink on synthetic polymer paint on canvas. 93¾ x 51¼ inches (238.1 x 130.2 cm)
Private collection. Courtesy of the Heller Group

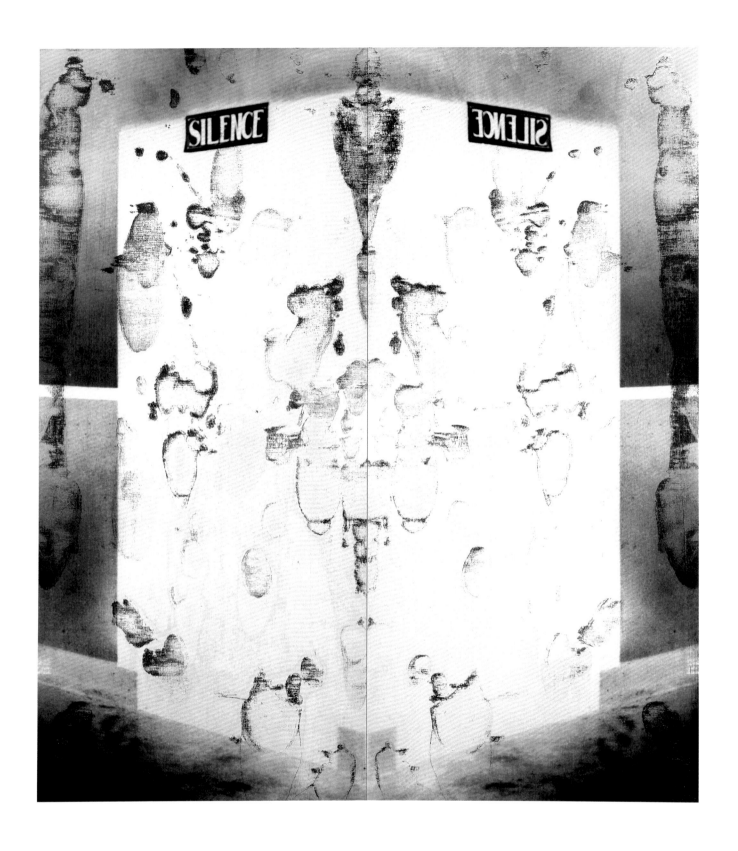

Christian Marclay, *White Rorschach Door (The Electric Chair)*, 2006

Silkscreen ink on synthetic polymer paint on canvas. 93¾ x 84 inches (238.1 x 213.4 cm)
From the collection of Susan Sosnick

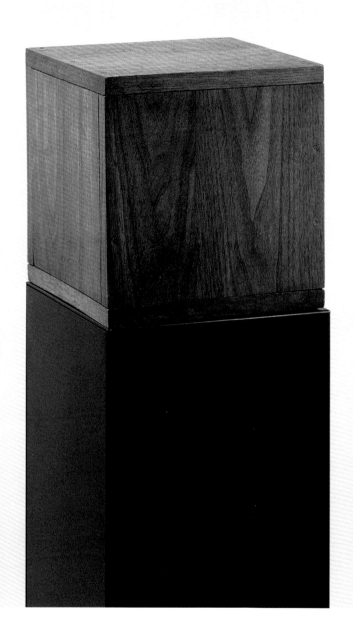

Robert Morris, *Box with the Sound of Its Own Making*, 1961

Wood, speaker, and sound recording (audiotapes transferred to CD by the artist)
9¾ x 9¾ x 9¾ inches (24.8 x 24.8 x 24.8 cm), audio run time: 3 hr. 30 min.
Seattle Art Museum, Gift of Mr. and Mrs. Bagley Wright

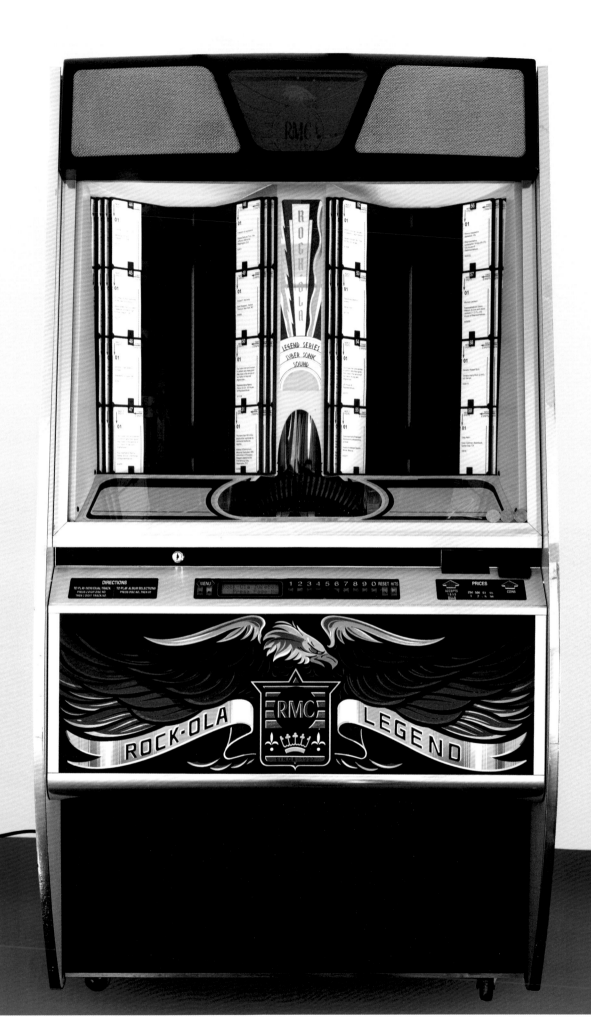

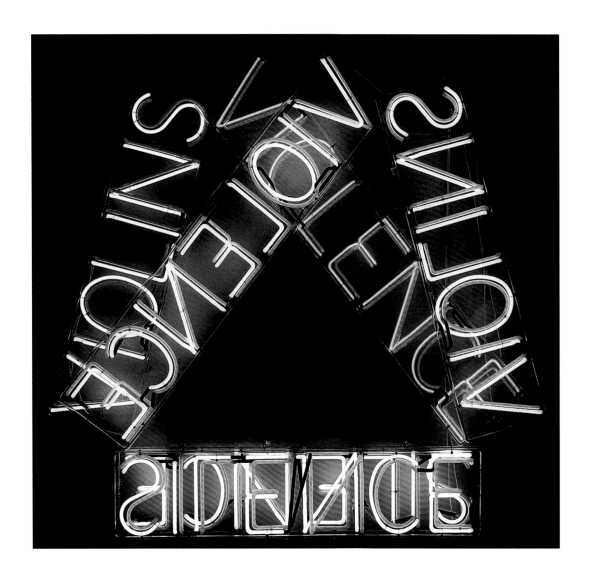

Bruce Nauman, *Violins Violence Silence*, 1981–82

Neon tubing with clear glass tubing suspension frame. 60½ x 66½ x 6 inches (153.7 x 168.9 x 15.2 cm)
ARTIST ROOMS. Tate and National Galleries of Scotland. Lent by Anthony d'Offay, 2012. Exhibition copy

OPPOSITE: Kurt Mueller, *Cenotaph*, 2011

Rock-Ola "Legend" 100-CD jukebox with collected silences. 65 x 37 x 28 inches (165.1 x 94 x 71.1 cm)
Courtesy of the artist. Commissioned and produced by Artpace San Antonio

Max Neuhaus, *Sound Figure*, 2007

Site-specific sound installation. 144 x 144 inches (365.8 x 365.8 cm)
The Menil Collection, Houston. Courtesy of the Estate of Max Neuhaus
(In background: Walter De Maria, *The Statement Series*)

Amalia Pica, *Sorry for the Metaphor*, 2005

A3 photocopies. 132¼ x 186 inches (336 x 472 cm)
Collection Rabobank, The Netherlands
Courtesy of the artist, Galerie Diana Stigter, Amsterdam, and Marc Foxx Gallery, Los Angeles

Robert Rauschenberg, *White Painting (Two Panel)*, 1951

Oil on canvas. 72 x 96 inches (182.9 x 243.8 cm)
The Robert Rauschenberg Foundation, New York

OPPOSITE: Ad Reinhardt, *Abstract Painting, 1954–1960, 80 x 50*

Oil on canvas. 80⅛ x 50⅛ inches (203.5 x 127.3 cm)
The Menil Collection, Houston

Steve Roden, *Listen (4'33")*, **2002**

Acrylic and oil on linen. 30 x 30 inches (76.2 x 76.2 cm)
Collection of Geoff Tuck and David Richards
Courtesy of Susanne Vielmetter Los Angeles Projects and CRG Gallery, New York

i perform 4'33" with two tiny wads of crumpled tissue in my ears.

during the first 30 seconds i hear mostly the sound of the tissue expanding, the crackling sounds suggesting a micro-version of takehisa kosugi's 1964 score "micro 1", where the artist crushes a very large piece of paper into a "light bundle" and rests it on a standing microphone. as the paper begins to expand, the microphone amplifies the sounds of the expanding paper, which moves from frenetic thunder and lightning to sporadic, barely audible, delicate crinkle-ings.

between these two sonic experiences with crumpled paper there is a suggestion that volume can come about in two distinctly different ways:

one is to raise the level of the sound so it can travel towards the body. the other involves the body moving closer to the sound.

one, has the potential towards sound as architecture; the other, sound as intimacy.

time into distance:

minutes & seconds	=	feet & inches
0'30"	=	0' 6"
2'23"	=	2' 4.6"
1'40"	=	1' 8"
-----		-----
4'33" in time	=	4' 6.6" in distance

some beginnings:

1. moving down from the top of a canvas, i mark three straight lines - one at 6 inches, one at 2 feet 10.6 inches, and one at 4 feet 6.6 inches. the lines delineating three fields relational to the timing each movement.

2. i paint four broad vertical lines across a canvas, and thirty-three thin horizontals.

3. a square canvas, each side measuring 4 feet and 33 inches (or 6 feet and 9 inches), broken into three parts, spaces related to the timing each movement.

also, the word "tacet" in inches:
T = 20, A = 1, C = 3, E = 5, T = 20... three times.

Steve Roden, Excerpt from *365 x 433*, 2011

Four books of text documenting the artist's daily performance of *4'33"*
Each page 8½ x 8½ inches (21.6 x 21.6 cm). Designed by Adrienne Wong
Courtesy of Susanne Vielmetter Los Angeles Projects and CRG Gallery, New York

Steve Roden, *Tacet Permutations*, 2012

Acrylic and oil on linen. 81 x 81 inches (205.7 x 205.7 cm)
Courtesy of Susanne Vielmetter Los Angeles Projects and CRG Gallery, New York

Steve Roden, *866 (silence and light)*, 2012

Wood, wire, plastic, cloth, and acrylic sheet. 35 x 33½ x 21 inches (88.9 x 85.1 x 53.3 cm)
Courtesy of Susanne Vielmetter Los Angeles Projects and CRG Gallery, New York

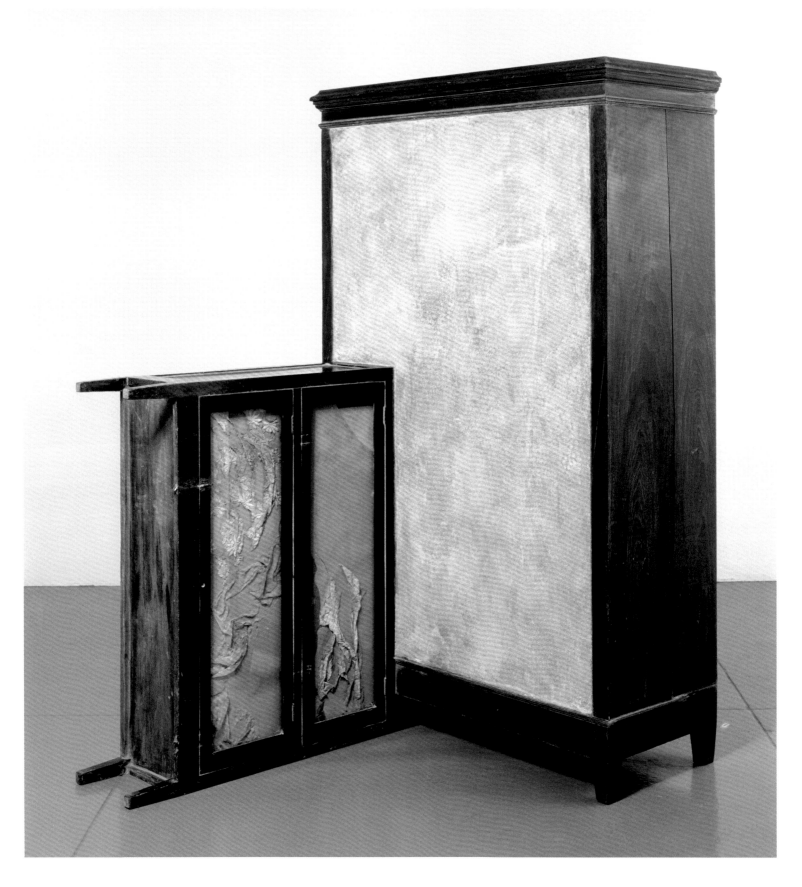

Doris Salcedo, *Untitled*, 2001
Wood, concrete, glass, fabric, and steel. 80⅛ x 67 x 50 inches (203.5 x 170.2 x 127 cm)
The Rachofsky Collection, Dallas

Tino Sehgal, *Instead of allowing something to rise up to your face dancing bruce and dan and other things*, 2000

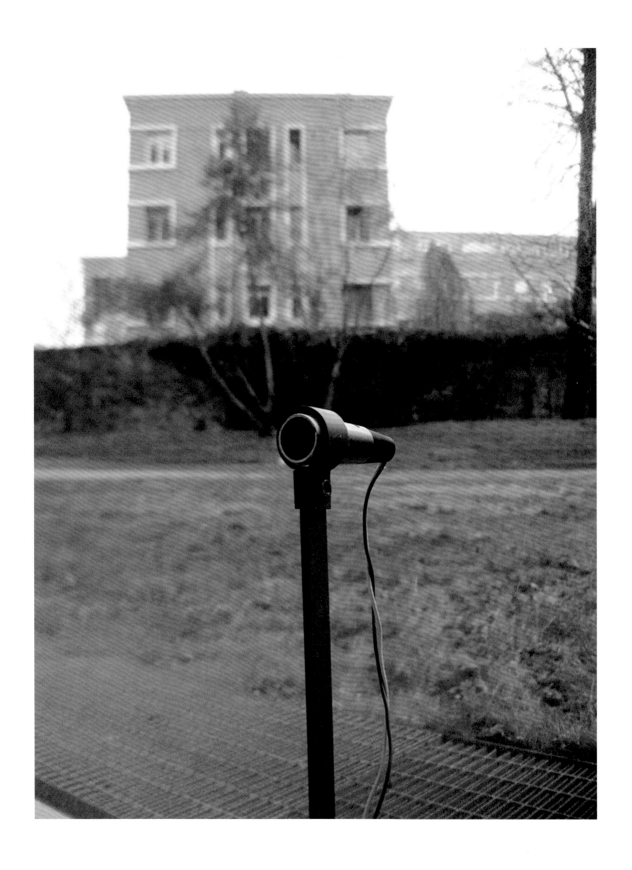

Stephen Vitiello, *Light Readings (Menil/Berkeley Version)***, 2012**

Photocells, microphone, computer, amplifiers, and speakers
Courtesy of the artist and American Contemporary, New York
(Pictured: *Light Readings [Cartier Version]*, 2002)

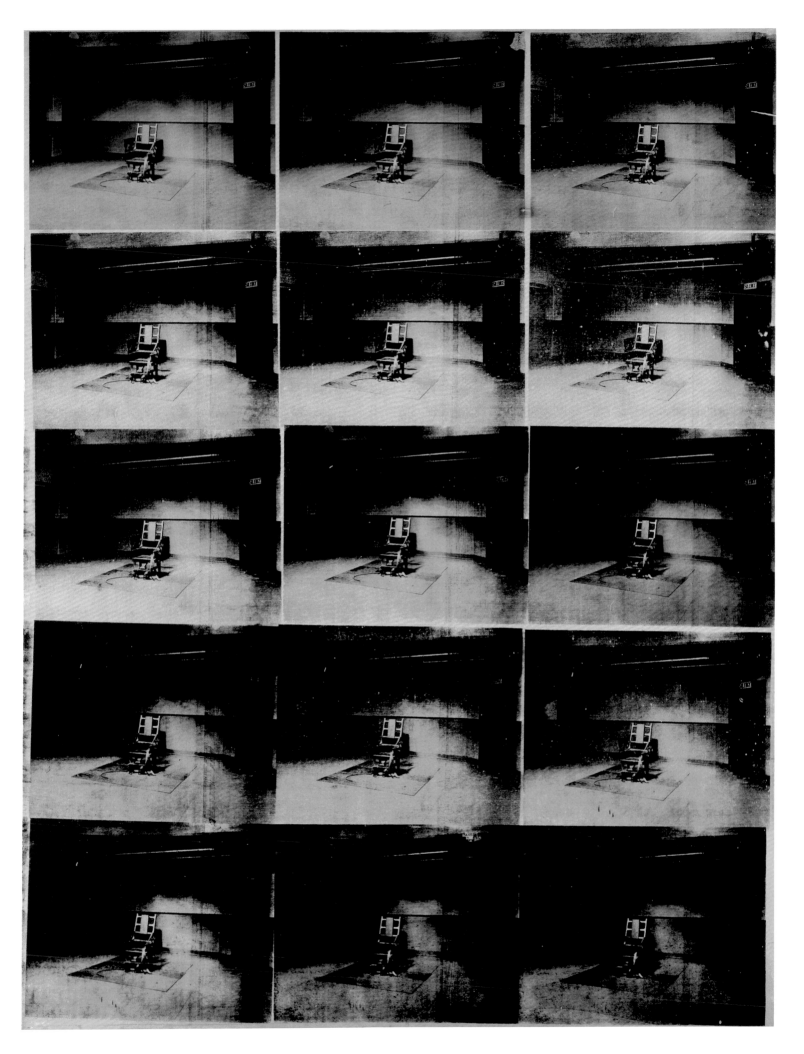

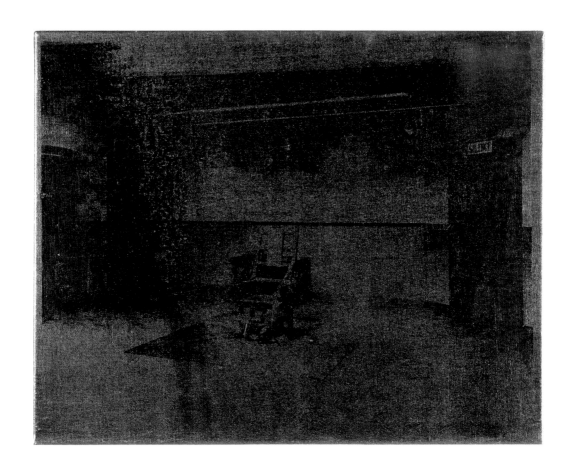

Andy Warhol, *Little Electric Chair*, 1965

Silkscreen ink and acrylic on linen. 22 x 28 inches (55.9 x 71.1 cm)
The Menil Collection, Houston

OPPOSITE: Andy Warhol, *Lavender Disaster*, 1963

Silkscreen ink, acrylic, and pencil on linen. 106 x 81⅞ inches (269.2 x 208 cm)
The Menil Collection, Houston (Houston only)

Andy Warhol, *Big Electric Chair*, **1967**

Silkscreen ink and acrylic on linen. 54¼ x 74 inches (137.7 x 188 cm)
The Menil Collection, Houston

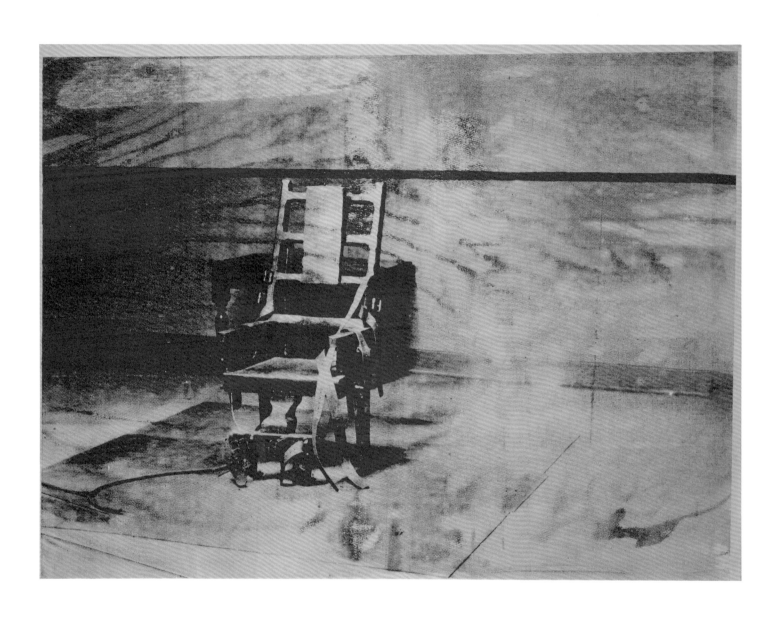

Andy Warhol, *Big Electric Chair*, 1967

Silkscreen ink and acrylic on linen. 54 x 73⅛ inches (137.2 x 185.7 cm)
The Menil Collection, Houston, Gift of the artist

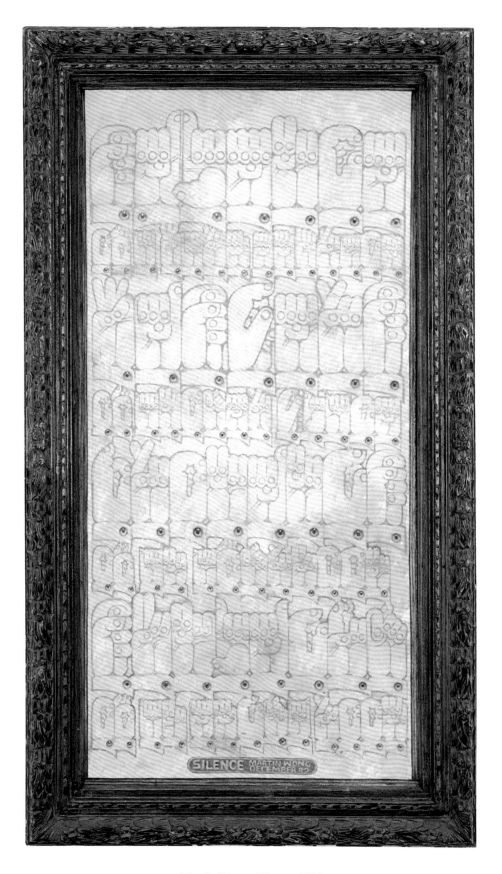

Martin Wong, *Silence*, 1982

Acrylic on canvas. 56 x 31½ inches (142.2 x 80 cm)
Courtesy of the Estate of Martin Wong and P.P.O.W. Gallery, New York

(. . .)

Toby Kamps

The art of our time is noisy with appeals for silence.
—Susan Sontag[1]

Silence is the best art one can produce: It is unsigned and for the benefit of everyone.
—Marcel Duchamp[2]

Whereof one cannot speak, thereof one must be silent.
—Ludwig Wittgenstein, *Tractatus Logico-Philosophicus*[3]

Something mysteriously formed,
Born before heaven and earth.
In silence and the void,
Standing alone and unchanging,
Ever present and in motion.
Perhaps it's the mother of ten thousand things.
I do not know its name
Call it Tao.
—Lao Tzu, *Tao Te Ching*[4]

That most famous deployment of avant-garde silences, John Cage's *4'33"*, made its debut at the Maverick Concert Hall in Woodstock, New York, on August 29, 1952. The twenty-six-year-old virtuoso pianist David Tudor stepped onto the stage of the partially covered wooden hall and performed the composition by closing the keyboard cover at the beginning of the piece and then opening and reclosing it between its three movements, of 30", 2'23", and 1'40". Keeping track of time by consulting a stopwatch and reading a now lost, blank staff-notation score in 4/4 time, Tudor did not play a single note. Instead, he sat in concentration, letting the listeners react to this musical nonevent. The response, even from an audience accustomed to experimentation, was not positive. Many felt *4'33"* was an arrogant joke, and, during the question and answer session, it was even proposed that Cage and Tudor be run out of town.[5]

For Cage, however, *4'33"* was absolutely serious. Far from a stunt, the work stood as the culmination of years of research into alternate models of music and consciousness. Indian classical arts in particular impressed him with the view that "art imitates nature in her manner of operation."[6] From this standpoint, the main function of art is not representation in any conventional sense but should be understood instead as a *process* by which the artwork opens onto, and thus illuminates, the time, space, and context in which it is located. Although Cage was unclear on whether his formal studies of Buddhism predate *4'33"*, the piece clearly has deep correspondences with the philosophy of Zen. Cage's silent composition, like all of his work, stresses the limits of reason, awareness of the present moment,

and, perhaps, the idea that emptiness can represent a form of transcendence.[7] In addition to Eastern influences, however, *4'33"* was shaped by Cage's 1951 visit to an anechoic chamber at Harvard University where, in the quietest of all possible environments, he was surprised to hear two distinct sounds: the low tones of his blood's circulation and the higher-frequency buzz of his nervous system. "There's no such thing as silence," Cage famously remarked after this experience.[8] Or, as he later said of the audience's response to the debut of *4'33"*:

> They missed the point. . . . What they thought was silence, because they didn't know how to listen, was full of accidental sounds. You could hear the wind stirring outside during the first movement. During the second, raindrops began pattering on the roof, and during the third the people themselves made all kinds of interesting sounds as they talked or walked out.[9]

Music, Cage asserted, happens all around us all the time. A quiet, if not actually silent, call for attention and openness, *4'33"* has become a cult classic and familiar staple in new music programs around the world, and an American Zen koan—a riddle that may perplex but also spark greater awareness.

"NO SUCH THING AS SILENCE"

The silent big bang inspiring this exhibition, *4'33"* was a watershed event in the avant-garde's ongoing subversion of art and music, and all that lies between. It was not just the twentieth-century avant-garde, however, that looked to silence as a core value of artistic experience. The Romantic poet John Keats, writing in his acclaimed "Ode on a Grecian Urn" of 1819, addresses his eponymous subject as "thou foster-child of silence and slow time,"[10] suggesting a pervasive quietude that ties the art of the Classical past to his own poem. By the twentieth and twenty-first centuries, as artists pushed the boundaries of art into areas unimaginable to Keats and his contemporaries—into the "gap between art and life," as Robert Rauschenberg famously put it—silence became an important new subject and material in art's dialogue with "life." *Silence* examines a few of the many attempts in which artists have employed the absence of sound or speech over the last century: as a symbol, as a phenomenon, as a memorial device, as an oppressive force, and as something to be inhabited and explored through performance.

SYNESTHETIC SILENCE

In visual art, of course, summoning silence is a synesthetic endeavor. One medium must stimulate a response associated with another, much as the neurological condition of synesthesia can, for example, associate sound with sight. And, in the case of silence, since its absolute form exists only in the vacuum of deep space (or, we assume, in death), the artist must use something material to represent something immaterial.[11] For Cage's sound work *4'33"*, a key stimulus was an especially blank abstract image: Robert Rauschenberg's *White Painting (Two Panel)* and four other similar works from his 1951 White Paintings series. Made of white house paint applied by the artist (or later any of his designates) with a roller on canvas panels, which are joined to make the larger paintings, the White Paintings stand as one of Rauschenberg's earliest efforts to eliminate representation, symbolism, and any trace of his own personality from the work. In a letter to his dealer Betty Parsons, he describes them as a form of tabula rasa:

> They are large white (one white as one God) canvases organized and selected with the experience of time and presented with the innocence of a virgin. Dealing with the suspense, excitement, and body of an organic silence, the restriction and freedom of absence, the plastic fullness of nothing, the point a circle begins and ends. . . . It is completely irrelevant that I am making them. *Today* is their creator.[12]

Cage enthusiastically called the White Paintings "airports for the lights, shadows, and particles."[13] And Rauschenberg later corroborated this mirroring interpretation, saying, "I always thought of the white paintings as being not passive, but very—well, hypersensitive. So that one could look at them and almost see how many people were in the room by the shadows cast, or what time of day it was."[14] If *White Painting (Two Panel)* functions as a sounding board for the receptive mind, it is surely no coincidence that the vertical lines used to demarcate distances equivalent to lengths of time in Cage's 1953 proportional notation version of the score for *4'33"* resemble the vertical seams between the abutting panels from Rauschenberg's work.[15]

John Cage, printed score for *4'33"*, proportional notation version, 1953. Each page 11 x 8½ inches

SYMBOLIC SILENCE

Taking *4'33"* as exemplary, Susan Sontag in her powerful, wide-ranging 1967 essay "The Aesthetics of Silence" outlines an important tendency toward extreme reticence in modern art's most reductive strains. By the mid-twentieth century, Sontag argues, much nonrepresentational art acquires a new, spiritual function. But this function is grounded, not in any traditional form of transcendence, but in the materiality of art and its maker—a kind of existential-ist antispirituality.[16] By eliminating recognizable imagery that might link their minds to the external world, artists cultivate an internal, symbolic silence and a refusal to communicate on conventional levels. Sontag writes:

> As the activity of the mystic must end in a *via negativa*, a theology of God's absence, a craving for the cloud of unknowing beyond knowledge and for the silence beyond speech, so must art tend toward anti-art, the elimination of the "subject" (the "object," the "image"), the substitution of chance for intention, and the pursuit of silence.[17]

Be this as it may, a pictorial laconism can still be a spiritual project in a conventional sense, as critic Donald Kuspit and others have noted. If complete abstraction is a form of silence, then the artist must take on a shaman-like role: they must free themselves from the trappings of reality to give form to the ineffable.[18] In any case, as a Cistercian monk who spends much of his time without speaking notes, "silence is a place for bumping into yourself."[19] By eschewing language—literally and figuratively—the con-templative monk and the committed abstract artist place themselves at the center of awareness, consciousness, and the body's sensorium.

Sontag's claim that abstraction folds into a distinctly modernist negative theology is germane to the work of a number of painters in the exhibition. As with John Cage, Buddhism's concept of emptiness—along with Rosicrucian-ism's concepts of space and spirit—inspired the French artist Yves Klein. Calling this state "the void," and cultivat-ing it in all aspects of his work, Klein regarded it as a space of pure artistic possibility, free from the limits of materiality and individual personality. Speaking for the international group ZERO, with which Klein was associated, Otto Piene described their closely related concept of "zero" as a new beginning, "a zone of silence and of pure possibilities for a new beginning as at the count-down, when rockets take off."[20] Among Klein's many attempts to access the void are his *Symphonie Monoton—Silence (Monotone Symphony—Silence)*, 1947/61, a full orchestra composition in which one note is held for twenty minutes followed by twenty minutes of silence;[21] International Klein Blue, a legally copyrighted radiant blue pigment used to make a wide range of mono-chrome paintings; an exhibition consisting of an empty gallery; and the notorious *Leap into the Void* of 1960, a photograph of the artist hurling himself from a rooftop in an attempt at flight. Gold, because of its value, eternal qualities, and association with religious painting and architecture, also had a special significance for Klein in his efforts to express the void. *Untitled (Monogold)*, c. 1960, a monochrome of shining gold leaf on wood whose surface is interrupted by an irregular pattern of concave circles of different sizes,

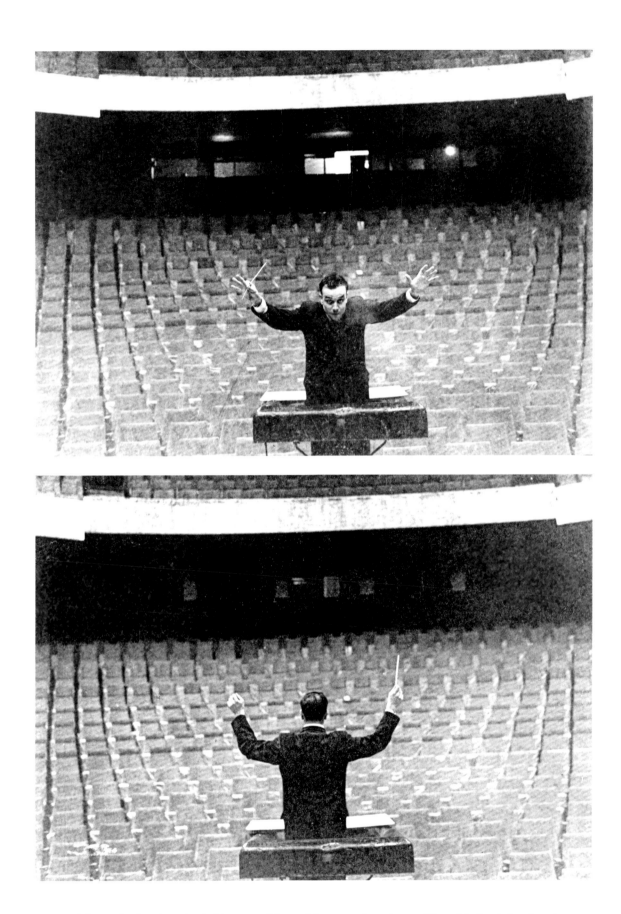

Yves Klein conducting *Symphonie Monoton—Silence (Monotone Symphony—Silence)*, in front of an imaginary orchestra, Gelsenkirchen Opera House, West Germany, 1959. Courtesy of the Yves Klein Archives

lending it an otherworldly, lunar aspect, seems a physical realization of Thomas Carlyle's famous maxim "silence is golden," which is the name of a similar Klein work of 1960.

As an expression of pictorial silence, and for all of their manifold differences, as blue and gold are to Klein and as white is to Rauschenberg, black is to Ad Reinhardt. Take Reinhardt's *Abstract Painting, 1954–1960, 80 x 50*, a nearly monochrome work save for the barely perceptible horizontal and vertical cross in the middle of its inky-black surface. Whereas Rauschenberg's canvases invite the unfettered flow of life into art, in 1967 Reinhardt described his black paintings in hermetic terms:

> a matte, flat, free-hand painted surface (glossless, textureless, non-linear, no hard edge, no soft edge) which does not reflect its surroundings—a pure, abstract, non-objective, timeless, spaceless, changeless, relationless, disinterested painting—an object that is self-conscious (no unconscious), ideal, transcendent, aware of no thing but art (absolutely no anti-art).[22]

Reinhardt, consistent with Sontag's claims regarding reductive abstraction, believed "you can only make absolute statements negatively."[23] A student of Eastern art and religions, Reinhardt followed an iconoclastic and visionary path, concentrating on what curator Alexandra Munroe calls "the ritualized and diagrammatic approach to object-making in Islamic as well as Asian cultures":[24]

> For Reinhardt, his art is a perceptual experience with the specific power—indeed the ethical mandate—to purify consciousness through the act of concentrated contemplation. Reinhardt shifted the conception of seeing from an optical event to a phenomenological process and made durational time (of looking at the painting) a medium of ontological awareness. The substance of that awareness is the coincident dematerialization of the painting and the self beholding it.[25]

Mark Rothko's eleven geometric paintings in the Rothko Chapel, which opened in 1971, have a similar vortical effect. These enormous canvases in velvety purples and blacks are, as the artist said of his work, expressions of "the most basic human emotions, tragedy, ecstasy and doom."[26] Under the dim, constantly changing natural lighting provided by the chapel's overhead oculus and light baffle, it is difficult to read the geometric images as coherent designs. They have an absorptive, engulfing effect and are as much emanations as images. Best

perceived in silence over time, the works are an invitation to look beyond the shapes and forms of everyday vision.

If these abstractions of Klein, Reinhardt, Rauschenberg, and Rothko open onto a pictorial image of silence, Jennie C. Jones in her recent work builds and comments on the forms and ideas of these painters by adding references to a nonvisual, sonic element, what she calls "the physical residue of music."[27] Made from the same high-tech, sound-absorbing and -diffusing materials found in recording studios, as well as acrylic paint and canvas, her mostly monochrome paintings, consisting of subtle shifts in color and texture, are given titles referencing musical notation, jazz, and Minimalist music: *Sustained Black with Broken Time and Undertone*; *Semitone-Bar*; *Resonance at 1/3*; *Deep Tone*; and *Long, Low, Rest (semibreve)*, all 2011. Originally accompanied at The Kitchen in New York City by a sound installation, *From the Low*, in which Jones sampled compositions by various musicians such as Charles Mingus and Ray Brown, the paintings—which dampen sounds in the space they occupy—delicately intertwine the legacies of two historical avant-gardes, one in visual art that was predominantly white and one in music that was predominantly black.

SURREAL SILENCE

Although it uses primarily representational means, Surrealism also attempts to penetrate surface appearances, looking to the unconscious as a source of inspiration and of a deeper artistic and social truth. Two well-known paintings in the Menil Collection depict silence in mysterious, symbolic imagery. Giorgio de Chirico, an Italian painter born in Greece, was an important early inspiration for the Surrealists. Inspired by Friedrich Nietzsche's love for the city of Turin and his critique of metaphysics, de Chirico's Piazza d'Italia series, comprising nearly vacant cityscapes filled with bright sunlight and dark shadows, suggests the "truth" only partially perceptible behind the veneer of the visible. In his autobiography, de Chirico describes Nietzsche's writings as "a strange and profound poetry, infinitely mysterious and solitary, based on [the] *Stimmung* (which might be translated as atmosphere) . . . of an autumn afternoon when the weather is clear and the shadows are longer than in summer."[28] *Melancholia*, 1916, might not be a literal depiction of silence: the pennants snapping in the wind, the tiny figures facing each other, and the train idling in the background all imply distant sounds. But the crisp shadows delineating the porticoes in the central square and its

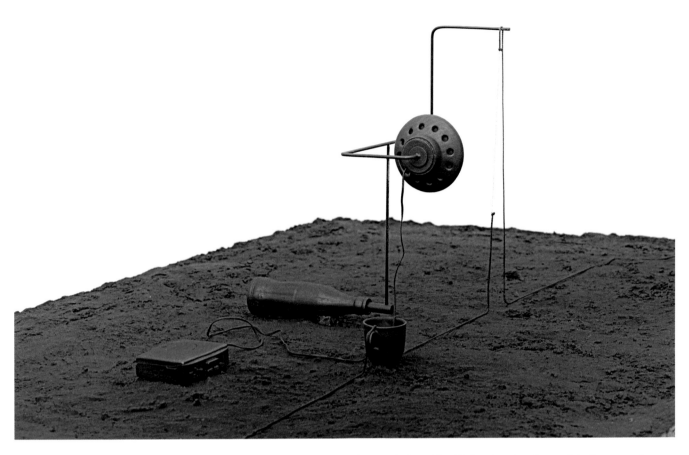

Mark Manders, *Reduced Summer Garden Night Scene (Reduced to 88%)*, 2011 (detail). Sand, painted porcelain, iron, wood, and rope, 33½ x 59⅜ x 39¾ inches. Courtesy of Zeno X Gallery, Antwerp, and Tanya Bonakdar Gallery, New York

Ariadne statue along with the work's slightly elevated vantage point lend it a pellucid stillness.

Just as Nietzsche influenced de Chirico, the Italian painter in his turn influenced the Belgian Surrealist René Magritte. As Magritte stated in 1938:

> [De Chirico] painted *Melancholia* in a landscape of tall factory chimneys and walls receding in an infinite distance. . . . It was a complete break with the mental habits peculiar to artists who are prisoners of talent, of virtuosity, and of all the little aesthetic specialties. Here we have a new vision in which the spectator rediscovers his isolation and hears the silence of the world.[29]

La chambre d'écoute (The Listening Room), 1952, an image of a giant green apple filling an otherwise bare room, reflects Magritte's attempt to expand on de Chirico's

soft-spoken estrangement. The work's uncanny scale shift and the room's closed windows suggest a claustrophobic muffling of sound. And the perfect apple—a recurring symbol in Magritte's work—may in this case be seen as a stand-in for an insensate human head, emblematizing its maker's paradoxical desire to make "the most everyday objects shriek aloud."[30]

Picking up these Surrealist threads in his recent sculptures and installations, Mark Manders, a Dutch artist working in Belgium, makes painstakingly precise constructions that capture the wild imprecision of thoughts and feelings. Depicting machines, interiors, and figures that seem to be from some just-out-of-reach place or past, his works are uncanny still lifes in which the buzz of everyday life is hushed. Manders has created two new works for this exhibition. *Reduced Summer Garden Night Scene (Reduced to 88%)*, 2011, is a diorama-like depiction of a still, nocturnal

garden in which mysterious physical and emotional forces are at play. Covered in a thin, black "night layer" of porcelain, this terrain includes a mute Walkman, a cup, and a loudspeaker "transected" by a rope, all of which have succumbed to "a melancholy gravitational pull."[31] Like many of Manders's sculptures, it is reduced to eighty-eight percent of life-size, a small yet disorienting scale shift that produces a Magritte-like unsettling effect. As Manders puts it, "The whole setting resembles a soundless three-dimensional night photograph."[32] Serving as a pendant, Manders's *Silent Head on Concrete Floor*, 2011, depicts a vertical slice of a head bound by straps between matte-black, piano key–like wooden slats. The work rests on a portion of a newspaper of the artist's invention that uses every word in the English language in random order, which in turn rests on a base resembling an excavated section of concrete floor like that found in his studio. Referencing musical chords, the modernist obsession with "primitive" works of art like the *moai* statues on Easter Island, and the workings of Manders's own associative mind, the head evokes the externally silent, internally clamorous nature of individual consciousness.

CAGE'S SILENCE

Other contemporary contributions to the exhibition respond more directly to Cage's long-echoing "silence." Dutch artist Manon de Boer's film installation *Two Times 4'33"*, 2008, negotiates a delicate balance between presenting and interpreting Cage's legendary work. In the first of its two sections, the camera focuses on Belgian pianist Jean-Luc Fafchamps as he sits down in a recital hall to perform the piece in front of a glass wall on a rainy day. The soundtrack includes the clicks of a chess timer, which Fafchamps hits to mark the end and beginning of each of the three movements, and the sounds of wind, rain, and traffic, and, eventually, after the pianist takes a bow and the screen goes black, applause and scraping chairs. In the film's second section, the camera starts with Fafchamps beginning to perform *4'33"*, but then slowly pans around the room, over the audience, and ends in a long shot of wind-blown trees and electrical wires outside the hall's windows. Other than the clicks of the pianist's chess timer, however, de Boer includes no sound at all in this part. Radio broadcasts of moments of silence nearly always include a room tone—ambient noise—to remind listeners that their nothing has some substance; de Boer's eerie audio void may come as close to depicting actual silence as is possible in any

medium. It disconnects the locative collaboration of eyes and ears and leaves the viewer in the realm of thought and sense memory—an experience that may not contradict Cage's belief in "no such thing as silence" but which prompts a different, more internal attention.

Cage regarded *4'33"* as one of his most important pieces and in a 1982 interview described its impact on his life and work: "I don't sit down to do it; I turn my attention toward it. I realize that it's going on continuously. So more and more, my attention, as now, is on it. More than anything else, it's the source of my enjoyment of life."[33] Cage's openness—to chance, to listening, to "life"—is a primary inspiration for the drawings, sculptures, and audio works of California visual and sound artist Steve Roden. We see this in, for example, Roden's translation of one system of notation, such as a musical score or a text, into another, generating colors, numbers of elements, or compositions in images. This process, he says, involves rules that are flexible enough to allow him to make his own intuitive decisions and "left turns."[34] To make the painting *Listen (4'33")*, 2002, Roden used the lengths of the words in Cage's dedication on the proportional notation version of the score to determine the lengths of the horizontal and vertical brushstrokes making up the abstract composition. In the sculpture *866 (silence and light)* and the painting *Tacet Permutations*, both 2012, he used the numerical units within *4'33"* to determine the dimensions of constituent parts. From January 1 to December 31, 2011, Roden performed his own versions of *4'33"* every day. His written record of these experiences, *365 x 433*, reflects his careful, often poetic observations of his environments, spheres of attention, and reflections as an artist, and it is featured in *Silence* as books of text.

Sound artist Stephen Vitiello translates Cage's observation that the natural world is continually composing music into the spectrum of visible light. In *Light Readings (Menil/Berkeley Version)*, 2012, the artist uses light-sensitive photocells, a computer, amplifiers, and speakers to transform the light in the galleries into sound. Unless the light changes dramatically or a visitor passes in front of a photocell, the work produces a quiet drone, which is interrupted every few minutes by short segments of ambient street sounds fed live by a microphone hidden outside the museum. Research for this work began while Vitiello was an artist-in-residence at New York City's World Trade Center, where he attached a photocell to a telescope to "listen" to the flickering lights of the city at night.

ON A
WALKWAY

LEADING TO
AN ENTRANCE

SOUND FORMS

A FIGURE

Max Neuhaus, drawing after *Sound Figure*, 2007. Colored pencil on paper, 22 x 26⅜ inches and 22 x 11½ inches. The Menil Collection, Houston, Gift of the artist. Courtesy of the Estate of Max Neuhaus

SONIC SILENCE

Silence, linguists have long argued, functions as an intrinsic component of communication. Speech therapists, for example, emphasize that the pauses between words are as important as the words themselves, while neuroscientists have recently observed that it is the silent intervals in music that most excite positive brain activity.[35] Summarizing this research, writer George Prochnik describes how the brain continually searches for closure, explaining that it is in silence that "the mind reaches out," forming new connections and sparking new ideas. This inextricable communicative relay between sound and silence appears, although just barely, in a permanent installation at the Menil Collection's main entrance—Max Neuhaus's 2007 *Sound Figure*. Taking sound and its absence as communicative counterpoints along a spatial and temporal continuum, the artist describes the work in a study drawing: "On a walkway/Leading to an entrance/

Sound forms/A figure."[36] As museum visitors walk through the corridor-like space, they pass through a "curtain" of subtle—indeed, barely perceptible—reverberating sound that seems to emanate from the low plants flanking the walkway or the open sky above. Intensely focused in one plane, this work, often missed by those walking quickly or engaged in conversation, functions as a sound threshold that activates the senses as one passes into a new realm.

Also in the exhibition, Robert Morris's *Box with the Sound of Its Own Making*, 1961, uses unexpected sound to confound the usual association of painting and sculpture with silence and reverie. A sculptor, painter, performer, and writer associated with Minimalism and Postminimalist installation art, Morris often uses language, measurement, and unconventional materials to make works that critique or philosophize on their own existence or form. In *Box with the Sound of Its Own Making*, he equipped a walnut

cube—not unlike the geometric sculptures of Donald Judd or Larry Bell—with a speaker and tape recorder playing a three-and-a-half-hour recording of the noises produced during its construction, including the sounds of Morris leaving the studio. "I wanted to oppose the ontology of the art object as a silent, timeless thing," Morris explained,[37] rejecting the long, "timeless" history of contemplative silence in art, from Keats's Classicism and Romanticism to Minimalism. By incorporating a recording of his work, Morris imbued the *Box* with a previously repressed form of artistic silence: one that focuses, not on the end product—the box—but on the literal sounds and silences that went into the necessary labor.

Morris's sculpture has an important predecessor in Marcel Duchamp's famous "assisted readymade" of 1916, *With Hidden Noise*. This consists of a ball of twine sandwiched between two metal plates, inside of which Walter Arensberg, the artist's patron, placed an object unknown to Duchamp that was intended to serve as a rattle. Attempting to "free the mind from the eye," Duchamp, an artist associated with Cubism, Orphism, Dada, and Surrealism, pioneered a protoconceptual strain of art that used readymades (recontextualized mundane objects), chance, and tongue-in-cheek humor to emphasize the artist's intention over traditional craft values. In *With Hidden Noise*, the artist could honestly claim ignorance about the "content" of his work. In fact, Duchamp was so committed to withdrawing as an artist, or "trying for a minimum of action, gradually," that in the 1930s he officially retired from the life of the artist to play chess.[38] "Silence," he joked, "is the best art one can produce: It is unsigned and for the benefit of everyone."[39]

SHOUTING SILENCE

In 1964, four years before Duchamp's death, German artist Joseph Beuys protested his predecessor's withdrawal from art-making in the "action performance" *Das Schweigen von Marcel Duchamp wird überbewertet (The Silence of Marcel Duchamp Is Overrated)*. During a live television broadcast, Beuys constructed an enigmatic environment using wood, bells, and his signature materials of fat and felt, then painted a cardboard sign with the work's titular phrase in a mixture of paint and chocolate—and later attached to it a still photograph of the event. Also repurposing commonplace objects and cultivating a distinctive artistic persona, Beuys was by his own admission deeply indebted to Duchamp. (Beuys's multiple *Noiseless*

Blackboard Eraser, 1974, a signed felt eraser, engages with the form of the Duchampian readymade while referencing the story of his rescue by Tatars who wrapped him in fat and felt after his dive-bomber was shot down during World War II.) But Beuys applied many of Duchamp's innovations as tools for "social sculpture," or what he envisioned as a free society inspired by creativity. Included in *Silence* in the form of a hand-painted, printed multiple derived from a photograph of the original cardboard poster, Beuys's *The Silence of Marcel Duchamp Is Overrated* is a cri de coeur—a shout to an artist who set so much in motion yet neglected, in another's opinion, to realize its full potential for societal change.

In marked contrast, Beuys thought the "silence" of Swedish director Ingmar Bergman was anything but overrated. Bergman's 1963 film *Tystnaden (The Silence)* is a psychological drama revolving around two sisters—one with a young son and one suffering from a terminal illness—set in a hotel in a nameless European country during a time of war. Controversial for its frank sex scenes, the film was a critical success because of its innovative cinematography and study of the limitations of language and communication. To make his 1973 sculptural multiple *Das Schweigen (The Silence)*, Beuys purchased copies of the film and plated their reels in zinc and copper, rendering them as mute sculptures. The work is a powerful emblem of the eponymous film and subject, as well as of a leaden time in Germany, when Cold War tensions, internal terrorism, and the horror of the Nazi past gripped the country.

MEMORIAL SILENCE

Cosmically, silence represents the alpha and omega of being. The Old Testament's First Book of Kings says that God shall be revealed, not in a burst of apocalyptic thunder, but in a "thin voice of silence,"[40] while Hamlet's famous last words, "The rest is silence," succinctly summarize the enigma of mortality. Silence in the face of loss—integral to the act of mourning—marks a central concern in the sculpture of Colombian artist Doris Salcedo, whose works reference the decades of violence plaguing her country. After interviewing survivors of paramilitary massacres, she makes work using intimate objects such as shoes or domestic furniture to evoke individual and national traumas. In *Untitled*, 2001, Salcedo grafted custom-made pieces of furniture—a dresser and an armoire—sealing all of their seams and cracks with a concrete-like substance containing lace and other signs of what she calls "the fragility of

life and the brutality of power."[41] Her works are not intended to be monuments to "the disappeared" but rather to suggest the suffocating effects of violence and death in a culture where fear and repression are so complete that the individual, including the artist herself, becomes impotent and mute. "In art," Salcedo says, "silence is already a language—a language prior to language—of the unexpressed and the inexpressible. . . . The silence of the victim of the violence in Colombia, my silence as an artist, and the silence of the viewer come together during the precise moment of contemplation . . ."[42]

Absent the elegiac tone that permeates Salcedo's work, Bruce Nauman's giant flashing neon *Violins Violence Silence*, 1981–82, brings the relation between silence and violence into direct contact. Nauman has linked three sibilant words to sardonically chart the perennial cultural dialectic of creation and destruction. Rendered in a tawdry medium more often associated with commercial signs than art museums, the work functions as an ultracompact historical melodrama. It outlines an essential contradiction in human nature by referencing the behavioral poles of enlightenment and high culture (violins), and aggression and destruction (violence), as well as the silence that often accompanies transitions between the two. Originally a window installation, the words of *Violins Violence Silence* appear twice, written in different directions so as to be legible from inside and outside. As it buzzes and blinks, waving semaphore-style the near-homophonic words "violins" and "violence" on its sides, the work broadcasts a mindlessly mechanical *Reader's Digest* version of civilization's terrible paradoxes.

During the AIDS epidemic of the late 1980s, Nauman's neon and Hamlet's last words had a powerful echo in the logo developed by the Silence = Death Collective and translated by the collaborative Gran Fury into a glowing sign that used the pink triangle identifying homosexuals in Nazi concentration camps to angrily link the Holocaust to the culture of fear and apathy surrounding the disease. This message reverberates in Andreas Sterzing's staged photograph of artist and activist David Wojnarowicz having his lips sewn shut.

Kurt Mueller's *Cenotaph*, 2011, also uses a gaudy barroom medium to memorial effect. Consisting of a glowing Rock-Ola "Legend" jukebox filled with ninety-nine CD recordings of moments of silence, the work is, as its funereal title ("empty tomb") suggests, an unlikely device of commemoration. Moments of silence became popular

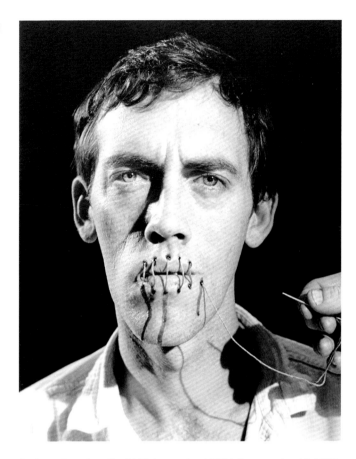

Andreas Sterzing, *David Wojnarowicz 1989 (silence = death)*, 1989. Gelatin silver print, approx. 12½ x 11 inches. Courtesy of the artist

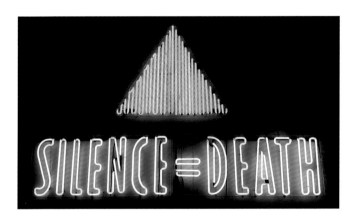

Gran Fury, *Silence = Death*, 1987. Neon tubing, 48 x 79 inches. Collection of the New Museum, New York, acquired from the William Olander Memorial Fund, June 11, 1991

in 1919, a year after the end of World War I, when England began recognizing two minutes of silence daily to honor the fallen. Eventually broadcast on the radio in 1929, this silent pause was, according to the BBC, "a solvent which destroys personality and gives us leave to be great and universal."[43] Ranging from the siren-demarcated memorial minutes for the fallen that precede Israel's independence day, to a remembrance of driver Dale Earnhardt during a thundering NASCAR race, to the United States Congress's recent pauses to remember troops in Iraq and Afghanistan, *Cenotaph*'s moments of silence are neither particularly silent nor sustained. Filled with all manner of ambient noise and of wildly varying length and concentration, the recorded memorial moments in *Cenotaph* document the struggles of the living to meditate on mortality and history.

Named for the ancient Greek word for "infinity" or "eternity," the 2006 video *AION* by Danish artist Jacob Kirkegaard was shot inside decaying buildings in the dangerously radioactive zone surrounding Chernobyl, Ukraine, which was evacuated in 1986 after a nuclear reactor explosion. Working fast to limit his exposure, Kirkegaard set up a camera, microphone, and speaker system in an abandoned swimming pool, a concert hall, a gymnasium, and a village church. Borrowing a concept developed by composer Alvin Lucier in his 1970 *"I am sitting in a room,"* Kirkegaard, while shooting video, recorded the room tone of each of the spaces, then played it back multiple times while rerecording it until the sound waves in the actual space and of the playback began to interfere with each other, creating jarring distortions and gaps. Later, in his studio, he projected and rerecorded his video footage of the spaces and experimented with layers, overexposure, and video feedback that serve as visual analogues to his sound experiments. *AION* is a haunting memorial to a tragedy. Its shifting and morphing sounds and images bring to life a place and event that seems caught in the amber of silent memory.

Kurt Mueller, *Cenotaph*, 2011 (detail). Rock-Ola "Legend" 100-CD jukebox with collected silences, 65 x 37 x 28 inches. Courtesy of the artist. Commissioned and produced by Artpace San Antonio

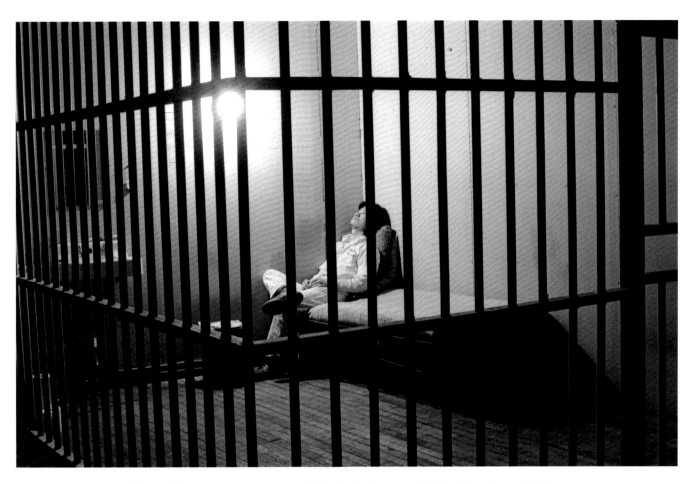

Tehching Hsieh, *One Year Performance 1978–1979*, Life image. Gelatin silver print, 10 x 15 inches.
Courtesy of the artist and Sean Kelly Gallery, New York

ENFORCED SILENCE

Silence can be a source of great comfort, but it also can be a form of punishment. Shunning, solitary confinement, and excommunication are all means to push an individual outside the comfortable clamor of the mainstream. David Hammons's "body prints," impressions of his own body made using margarine and powdered pigment, are explicit images of the toxic effects of prejudice, repression, and silencing. *Injustice Case*, 1970, an imprint of the artist bound and gagged in a chair, may reference the gagging of Black Panther Bobby Seale during his trial as one of the "Chicago Eight" charged with disrupting the 1968 Democratic Convention, as well as the historical contortions of American politics to justify slavery. Framed by an American flag, the work is a searing image of the ugly legacy of unequal justice and access to free political speech for African Americans and an early milestone in Hammons's alchemical career of transforming everyday objects into expressions of black identity.

Quietude can also be self-directed, as in the case of the monk who takes a vow of silence or the hermit who retreats to a mountaintop. In *One Year Performance 1978–1979*, Taiwanese-born artist Tehching Hsieh locked himself in a 11'6" x 9' x 8' wood cage equipped with a cot, a light bulb, a bucket, and a wash basin inside a New York City loft and spent the year between September 30, 1978, and September 29, 1979, without talking, reading, writing, watching television, or listening to the radio. A lawyer certified and attested that Hsieh never left the cage, and a friend of the artist visited every day to deliver food, remove waste, and take a daily photograph of him. Visitors were allowed to witness the performance on specified days. Surviving this experience of extreme sensory deprivation by working to remain in the present moment and imagining parts of his tiny cell as "home" and "outside," Hsieh went on to make a series of One Year Performances that included spending 365 days without stepping inside any kind of building,

ONE YEAR PERFORMANCE
by *SAM HSIEH*

1978

SEPT	1 2 3 4 5 6 7 8 9 10 11 12 13 14 15 16 17 18 19 20 21 22 23 24 25 26 27 28 29 ⟨30⟩
OCT	1 2 3 4 5 6 7 8 9 10 11 12 13 14 15 16 17 18 19 20 ⟨21⟩ 22 23 24 25 26 27 28 29 30 31
NOV	1 2 3 4 5 6 7 8 9 10 ⟨11⟩ 12 13 14 15 16 17 18 19 20 21 22 23 24 25 26 27 28 29 30
DEC	1 ⟨2⟩ 3 4 5 6 7 8 9 10 11 12 13 14 15 16 17 18 19 20 21 22 ⟨23⟩ 24 25 26 27 28 29 30 31

1979

JAN	1 2 3 4 5 6 7 8 9 10 11 12 ⟨13⟩ 14 15 16 17 18 19 20 21 22 23 24 25 26 27 28 29 30 31
FEB	1 2 ⟨3⟩ 4 5 6 7 8 9 10 11 12 13 14 15 16 17 18 19 20 21 22 23 ⟨24⟩ 25 26 27 28
MAR	1 2 3 4 5 6 7 8 9 10 11 12 13 14 15 16 ⟨17⟩ 18 19 20 21 22 23 24 25 26 27 28 29 30 31
APR	1 2 3 4 5 6 ⟨7⟩ 8 9 10 11 12 13 14 15 16 17 18 19 20 21 22 23 24 25 26 27 ⟨28⟩ 29 30
MAY	1 2 3 4 5 6 7 8 9 10 11 12 13 14 15 16 17 18 ⟨19⟩ 20 21 22 23 24 25 26 27 28 29 30 31
JUNE	1 2 3 4 5 6 7 8 ⟨9⟩ 10 11 12 13 14 15 16 17 18 19 20 21 22 23 24 25 26 27 28 29 ⟨30⟩
JULY	1 2 3 4 5 6 7 8 9 10 11 12 13 14 15 16 17 18 19 20 ⟨21⟩ 22 23 24 25 26 27 28 29 30 31
AUG	1 2 3 4 5 6 7 8 9 10 ⟨11⟩ 12 13 14 15 16 17 18 19 20 21 22 23 24 25 26 27 28 29 30 31
SEPT	⟨1⟩ 2 3 4 5 6 7 8 9 10 11 12 13 14 ⟨15⟩ 16 17 18 19 20 21 22 23 24 25 26 27 28 ⟨29⟩ 30

■ Opening performance on September **30**, 1978 at 6:00 p.m.
■ Closing performance September **29**, 1979 at 6:00 p.m.
■ Open to public on dates circled from 11:00 a.m. to 5:00 p.m. 111 HUDSON ST 2FL N.Y.C. 10013

Tehching Hsieh, *One Year Performance 1978–1979*. Poster, 17 x 11 inches.
Courtesy of the artist and Sean Kelly Gallery, New York

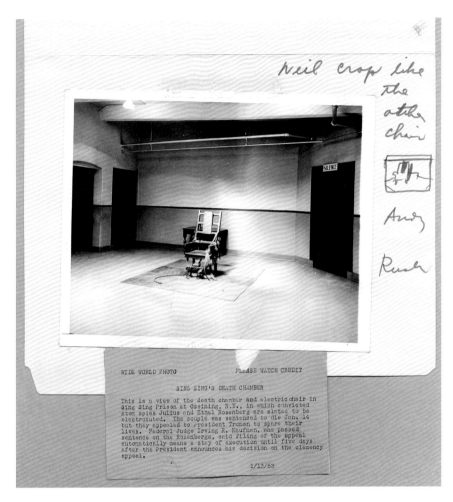

Andy Warhol, *Photograph ("Sing Sing's Death Chamber"), source for Warhol's 1963 Electric Chair Series*, 1962–63. Gelatin silver print and ink on manila folder, 20⅝ x 11⅞ inches. Collection of The Andy Warhol Museum, Pittsburgh

punching a time clock every hour, being tied to artist Linda Montano with a ten-foot length of rope, and, lastly, refusing to make, look at, or think about art. In the One Year Performances, critic Roberta Smith says, "Hsieh did not make his life his art. Instead, with Classical precision and unquestionable monstrousness, he expanded his art until it fully occupied, consumed and suspended his life."[44]

Of course, the most chilling and absolute form of silencing is execution. The death chamber at Sing Sing prison in New York is the main subject of an installation of the Menil's collection of Andy Warhol's Electric Chair silkscreen paintings and new works inspired by them by Christian Marclay, an artist who explores music and sound in a wide range of mediums. Marclay, who arranged the installation, says for him the crux of the Warhol pieces is the sign reading SILENCE over a door near to the electric chair: "It implies both authority and an audience . . . and it

reminded me of the sign 'INRI,' an abbreviation for 'Jesus of Nazareth, King of the Jews,' in images of the crucifixion."[45] In Warhol's electric chair images, this ritualized form of killing takes on banal and gruesome aspects in the grim institutional setting and garish, mopped-on silkscreen colors. But where Warhol employed the image of the chair and the door in works like *Little Electric Chair*, 1965, and zoomed in on just the chair in the paintings *Lavender Disaster*, 1963, and *Big Electric Chair*, 1967, Marclay, who worked with Warhol's original assistant Donald Sheridan to make silkscreens closely related in technique, focuses on the door, going so far as to give his paintings a door-like format and hanging them close to the floor. The door, he says, is a reference to Duchamp's famous *Étant donnés . . .* installation, in which a sprawled female is visible through a hole in a rough wooden door, and a nod to the idea of death representing a passage from one world to another.

Christian Marclay, study for The Electric Chair series, 2006.
Ink, pencil, and photocopy on paper, approx. 11 x 8 inches.
Collection of the artist

PERFORMING SILENCE

In theater and music, notes writer George Michelsen Foy, a well-placed break or pause in a performance serves a miraculous function: "It crushes the time frame in which both artist and audience lived before."[46] From Charlie Chaplin's silent films to the pantomimes of Mummenschanz to Butoh to Deborah Hay's dance, performance without dialogue or a soundtrack can have immense impact. As creatures highly attuned to body language, we relish the opportunity to take in a drama through the visual sense. And in the sonic void, the mind stretches to fill in information and to create its own narrative.

Such filling in of the blanks can be seen and, more to the point, heard in the single-channel, black-and-white video Mouth to Mouth, 1975, a multilayered, poetic reflection on language and identity by Korean American artist Theresa Hak Kyung Cha. Murdered in 1982 at the age of thirty-one, Cha, who immigrated to the United States at age twelve, made poetry, language, and text central elements in her video and performance work. In Mouth to Mouth, Cha superimposed Korean vowel graphemes—small components of larger characters—over shifting, never fully resolved images of her opening and closing mouth and video snow with a soundtrack of running water, bird songs, and waves. Evoking the loss of both her native language and the ability to speak, the work emblematizes the artist's cultural displacement as well as the myriad women throughout history who, by fate or circumstance, have not been able to speak for themselves.

A markedly different rapport with silence was assumed by Belgian artist Marcel Broodthaers, whose sculptures, rebus-like text works, performances, and films—in an innovative amalgam of Surrealist and Conceptual Art

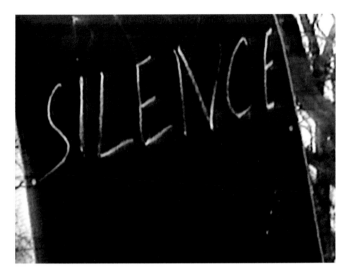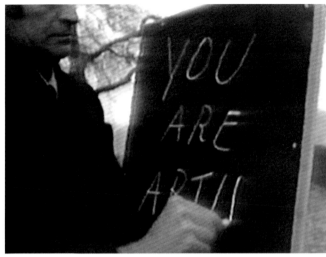

Marcel Broodthaers, *Speakers Corner*, 1972. 16mm film transferred to DVD, black-and-white, sound, approx. 16 min. 20 sec.
Courtesy of Marian Goodman Gallery, New York and Paris

strategies—continually question the role of the artist, the work of art, and the art-presenting institution. We see this, for example, in his 1972 performance *Speakers Corner*, documented in a video shot by art dealer Jack Wendler and others, in which Broodthaers traveled to the famous site of free speech and debate in London's Hyde Park. Rather than declaiming on a subject like politics or religion, as do most of the orators, Broodthaers remained mute, instead writing a series of short exhortations on a chalkboard, including "Attention," "Silence Please," "Visit Tate Gallery," "You Are Artists." As members of the noisy crowd laughed and teased him with singing, Broodthaers was silent and stoic—a Buster Keaton humorously and thoughtfully calling attention to art's marginal power.

If Broodthaers used silence to subvert a site of subversion, a similar quiet mischief takes place in the work of Scandinavians Michael Elmgreen and Ingar Dragset, ex-lovers who have collaborated since 1995 on a wide range of installations and performances. Elmgreen, a former poet, and Dragset, a former mime, infuse their spare works and environments with wry, oftentimes absurd humor, allowing room for alternate and queer readings of everyday life. Executed in their trademark refrigerator white, which references the neutrality of museum galleries as well as the idealism of Greek and Roman antiquities, *The Date*, 2009, is an example of the team's Powerless Structures, which aim to undermine authoritarian conventions of everyday life. This one consists of a locked door and adjacent videophone. On the phone's tiny screen, a would-be male suitor

carrying a rose rings the doorbell and waits in vain for someone to answer. Watching a classic silent minidrama of expectation fading to disappointment, the viewer can pick up the handset for a jolt of naturalism in the form of ambient street sounds. If not explicitly an image of the tribulations of gay romance, anachronistically "the love that dare not speak its name," the work is an emblem of the countless quiet tragedies occurring every day on streets around the world.

Martin Wong's 1982 painting *Silence* uses stylized hands to relate—in American Sign Language finger spelling—a short poem:

Silence
Of a lost embrace
W[h]ispers
Of another place
Dronings
Of an afternoon
Sunlight
Of an empty room.

Resembling Mayan hieroglyphs, the cuff-linked, chubby hands became a recurring motif in Wong's unique brand of sentimental realism, which stemmed from his deep love of New York's gritty Lower East Side. Born in Portland, Oregon, and reared in San Francisco, the artist, who died of AIDS in 1999, moved to New York in 1978 and immersed himself in the vibrant Latino, African American, artistic, and gay subcultures of *Loisaida*, as the neighborhood is called

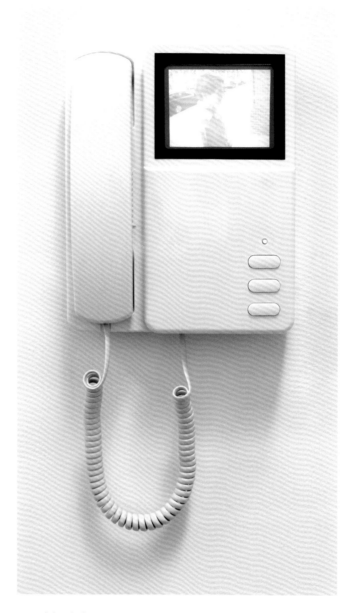

Michael Elmgreen & Ingar Dragset, *The Date*, 2009 (detail).
Wood, paint, door handle, security chain, hinges,
videophone, and transformer, door: 85⅝ x 45⅛ x ¾ inches,
videophone: 8¾ x 3⅛ x 2⅜ inches.
Courtesy of Galleri Nicolai Wallner, Copenhagen

in Spanish slang. There, he mixed with graffiti artists, hustlers, and writers, including his close friend Miguel Piñero—an acclaimed "outlaw" poet, performer, and playwright. Wong taught himself how to paint street scenes, portraits, and urban allegories in order to celebrate the beauty and tragedy surrounding him. And he claims to have invented the world's first painting for the hearing impaired in an autobiographical painting of 1978–81, *My Secret World*, which shows his small hotel room with

a finger spelling painting on the wall. A paradox in keeping with Wong's playful spirit, the already silent nature of painting is acknowledged and redoubled in his sign language images. Resembling saints' blessings and the obscure letters and symbols of the graffiti he loved, these gesticulating hands embody the quiet web of poetry Wong wove from his noisy neighborhood.

And then there is Tino Sehgal, an impresario of ephemeral, provocative art actions, who stages singing, dancing,

and conversational performances that invoke complex aesthetic and existential questions through simple human interaction. Sehgal's works for galleries include a performer singing "This is propaganda . . . a work by Tino Sehgal . . . ," a couple locked in a passionate kiss, and viewers being led up the spiral of New York City's Solomon R. Guggenheim Museum by a succession of progressively older performers while discussing the meaning of "progress." Consisting of a single dancer slowly writhing on the gallery floor, oblivious to the spectator, *Instead of allowing something to rise up to your face dancing bruce and dan and other things,* 2000, draws its inspiration and form from three early works by Bruce Nauman and Dan Graham: Nauman's *Wall-Floor Positions* of 1968, a video in which the artist tests poses at the title's vertical-horizontal juncture; Nauman's *Elke Allowing the Floor to Rise Up Over Her, Face Up,* a 1973 video of a woman imagining sinking into the studio floor; and Graham's *Roll,* 1970, a double film projection with images of the artist rolling down a forested hill holding a Super-8 camera and of the swirling footage shot with the camera. Sehgal, who was trained as a dancer, rejects nearly all of the ways in which conventional art objects have been subject to commodification, including documentary photography, contracts, and wall labels, focusing instead on his work's ability to prompt bodily awareness and communication. Watching the dancer in *Instead of allowing something to rise up to your face dancing bruce and dan and other things* roll as if in a fitful sleep or silent agony, one is reminded of Joseph Conrad's immortal line from the 1899 novel *Heart of Darkness,* "we live, as we dream—alone," and of the isolation all strive to overcome.

Finally, look at *Sorry for the Metaphor,* 2005, a photograph greatly enlarged and composited on photocopied pages by the Argentinean, London-based artist Amalia Pica, in which the artist poses in the Black Forest of Germany with a megaphone dangling by her side. The work, she says, is about the "guilt of not having something clear to say about the world."[47] As a Latin American and the daughter of a politically engaged mother who struggled against a corrupt government, Pica has a lingering belief that artists are obligated to be relevant to cultural discourse. The inoperative megaphone—a symbol of political agitation—and the title—a reference to Chilean writer Roberto Bolaño's observation that figures of speech are inadequate to spark social change—are emblems of this frustration. And the sumptuous wooded landscape, of the type favored by the German Romantic painter Caspar David Friedrich in his famous images of individuals confronting the sublimity of nature, along with the degraded quality of the image, forms an ironic backdrop that highlights Pica's as-yet-not-entirely-successful search for an authentic and effective artistic voice.

In many ways, Pica's overawed self-portrait is representative of all the artists in *Silence*. As Cage noted, silence is a distinctly human phenomenon—something that must be imagined to be experienced. Its absolute form can never exist on Earth, where even the deaf must "listen" to the continual white noise of consciousness. Yet silence, that most elusive of subjects, is embedded in the form and content of religion, philosophy, and politics, and across the arts. It is an eternal preoccupation, an idealized goal, and perhaps a final destination for all beings. Scarce and charged with power and mystery, it is something that must be carefully extracted or synthesized from experience, like a precious jewel. By conjuring, searching for, attempting to inhabit silence, the artist puts herself in the center of being and the universe. In 1953, in his psychological study of art history *The Voices of Silence*, André Malraux said, "All art is a revolt against man's fate," that is, a challenge to death and oblivion. Representational, allegorical, symbolic, or other "non-silent" images may, as Malraux poetically wrote, "be murmurous with the myriad secret voices which generations unborn will elicit from them."[48] But the silence-engaged artist attempts to access those secret, silent voices immediately and directly. She searches for an eternal sublime larger than and unmediated by the noise of this world and its inhabitants.

Notes

1. Susan Sontag, "The Aesthetics of Silence" (1967), in *Styles of Radical Will* (New York: Farrar, Straus and Giroux, 1969), 12.

2. Marcel Duchamp, quoted in Georges Charbonnier, *Entretiens avec Marcel Duchamp* (Marseille: André Dimanche, 1994), 91–92, cited in Aurélie Verdier, "The Silence-Fiction of Marcel Duchamp," in *MARTa schweigt: Garde le silence, le silence te gardera—Die Kunst der Stille von Duchamp bis heute* (Herford, Germany: MARTa, 2007), 238.

3. Ludwig Wittgenstein, *Tractatus Logico-Philosophicus* (New York: Harcourt Brace, 1922), 23.

4. From Chapter 25, the version transliterated/translated as Lao Tsu (Laozi), *Tao Te Ching* (Daodejing), trans. Gia-Fu Feng and Jane English, with introduction and notes by Jacob Needleman (New York: Vintage Books, 1989), 27.

5. Kyle Gann, *No Such Thing as Silence: John Cage's 4'33"* (New Haven, CT: Yale University Press, 2010), 8.

6. Ananda K. Coomaraswamy, "Why Exhibit Works of Art?" *Journal of Aesthetics and Art Criticism* 1: 2/3 (Autumn 1941): 38, quoted in Gann, *No Such Thing as Silence,* 93.

7. Gann, *No Such Thing as Silence,* 105.

8. John Cage, interview by John Kobler, "Everything We Do Is Music," *The Saturday Evening Post*, October 19, 1968, quoted in Richard Kostelanetz, *Conversing with Cage* (New York: Limelight Editions, 1988), 65.

9. Cage, interview by John Kobler, 65.

10. John Keats, "Ode on a Grecian Urn" (1819), in *The Norton Anthology of English Literature*, 4th ed. (New York and London: W.W. Norton, 1979), 2:825.

11. See Hamza Walker, "Silence = Rose," *Several Silences* (Chicago: Renaissance Society, 2009), http://www.renaissancesociety.org/site/Exhibitions/Essay.Several-Silences.604.html (accessed November 10, 2011).

12. Robert Rauschenberg to Betty Parsons, envelope postmarked October 18, 1951, illustrated in Walter Hopps, *Robert Rauschenberg: The Early 1950s* (Houston: The Menil Collection and Houston Fine Arts Press, 1991), 230.

13. John Cage, "On Robert Rauschenberg, Artist, and His Work," in *Silence: Lectures and Writings* (Middletown, CT: Wesleyan University Press, 1961), 102.

14. Robert Rauschenberg, quoted in Calvin Tomkins, *The Bride and the Bachelors: Five Masters of the Avant-Garde,* expanded ed. (New York: Penguin, 1976), 203.

15. Larry J. Solomon, "The Sounds of Silence: John Cage and 4'33"," 2002, http://solomonsmusic.net/4min33se.htm (accessed September 26, 2011).

16. Sontag, "The Aesthetics of Silence," 5.

17. Sontag, "The Aesthetics of Silence," 4–5.

18. Donald Kuspit, "Concerning the Spiritual in Contemporary Art," in *The Spiritual in Art: Abstract Painting, 1890–1985,* by Maurice Tuchman et al. (Los Angeles: Los Angeles County Museum of Art; New York: Harry N. Abrams, 1986), 314.

19. Alberic, a Cistercian monk, quoted in George Prochnik, *In Pursuit of Silence: Listening for Meaning in a World of Noise* (New York: Anchor, 2010), 27.

20. Otto Piene, quoted in Valerie L. Hillings, "Pure Possibilities for a New Beginning: Zero (1957–1966) and the Geography of Collaboration," in *ZERO in New York* (New York: Sperone Westwater, 2008), 179.

21. As Klein described his composition: "It exists outside of the phenomenology of time because it is neither born nor will it die." "Overcoming the Problematics of Art," in *Overcoming the Problematics of Art: The Writings of Yves Klein*, ed. and trans. Klaus Ottmann (Putnam, CT: Spring Publications, 2007), 47.

22. Ad Reinhardt, "[The Black-Square Paintings]" (1963), in *Art-As-Art: The Selected Writings of Ad Reinhardt,* ed. Barbara Rose (1971; repr. Berkeley and Los Angeles: University of California Press, 1991), 82–83.

23. Ad Reinhardt, quoted in Robyn Denny and Phylisann Kallick, "Ad Reinhardt," *Studio* 174 (December 1967): 264, cited in Kuspit, "Concerning the Spiritual in Contemporary Art," 317.

24. Alexandra Munroe, "Art of Perceptual Experience," in *The Third Mind: American Artists Contemplate Asia, 1860–1989* (New York: Solomon R. Guggenheim Museum, distributed by D.A.P./Distributed Art Publishers, New York, 2009), 287.

25. Munroe, "Art of Perceptual Experience," 287–88.

26. Mark Rothko, in Selden Rodman, *Conversations with Artists* (New York: Devin-Adair, 1957), 93, cited in Pia Gottschaller, "The Rothko Chapel: Toward the Infinite," in *Art and Activism: Projects of John and Dominique de Menil,* ed. Josef Helfenstein and Laureen Schipsi (Houston: The Menil Collection; distributed by Yale University Press, New Haven, CT, 2010), 142.

27. Jennie C. Jones, quoted in Stephen Vitiello, "Artists on Artists: Jennie C. Jones by Stephen Vitiello," *BOMB Magazine*, no. 118 (Winter 2012): 85.

28. Giorgio de Chirico, *Memorie della Mia Vita* (Rome: Astrolabio, 1945), 9, cited in James Thrall Soby, *Giorgio de Chirico* (New York: Museum of Modern Art, 1955), 28.

29. René Magritte, "*La Ligne de vie*" (lecture, Musée Royal des Beaux-Arts, Antwerp, November 20, 1938), reproduced in *Secret Affinities: Words and Images by René Magritte* (Houston: Institute for the Arts, Rice University, 1976), 4.

30. René Magritte, quoted in *René Magritte: Catalogue Raisonné, Vol. 5,* ed. David Sylvester (Antwerp: Fonds Mercator, 1997), 19.

31. Mark Manders, email to the author, November 30, 2011.

32. Mark Manders, email to the author, May 24, 2011.

33. John Cage, quoted in *Cage at 75*, ed. Richard Fleming and William Duckworth (Lewisburg, PA: Bucknell University Press, 1989), 21–22, cited in Gann, *No Such Thing as Silence,* 186.

34. Steve Roden, "Bio," *steve roden / in be tween noise,* http://www.inbetweennoise.com/bio.html (accessed November 4, 2011).

35. Prochnik, *In Pursuit of Silence,* 14.

36. Max Neuhaus, *Sound Figure*, 2007, colored pencil on paper, 22 x 26⅜ in. (56 x 67 cm) and 22 x 11½ in. (56 x 29cm), The Menil Collection, Houston, Gift of the artist.

37. Robert Morris, *From Mnemosyne to Clio: The Mirror to the Labyrinth (1998-1999-2000)* (Lyon: Musée d'art contemporain; Milan: Skira, 2000), 165.

38. Marcel Duchamp, quoted in Robert Storr, "The Romance of the Ready-Made" *Washington Post*, November 24, 1996, http://www.washingtonpost.com/wp-srv/style/longterm/books/reviews/duchamp.htm (accessed October 23, 2011). (Unofficially, Duchamp continued to work, unveiling his famous installation Étant donnés . . . , 1946–66, at the Philadelphia Museum of Art in 1969.)

39. Duchamp, quoted in Charbonnier, *Entretiens avec Marcel Duchamp*, 91–92, cited in Verdier, "The Silence-Fiction of Marcel Duchamp," 238.

40. Prochnik, *In Pursuit of Silence,* 8.

41. Doris Salcedo, quoted in "Compassion," *Art 21: Art in the Twenty-First Century, Season 5* (2009), http://www.pbs.org/art21/artists/doris-salcedo (accessed November 7, 2011).

42. Doris Salcedo, "Interview with Charles Merewether 1998," in *Doris Salcedo,* ed. Nancy Princenthal, Carlos Basualdo, and Andreas Huyssen (London: Phaidon, 2000), 137.

43. Prochnik, *In Pursuit of Silence,* 40.

44. Roberta Smith, "A Year in a Cage: A Life Shrunk to Expand Art," *New York Times*, February 19, 2009, http://www.nytimes.com/2009/02/19/arts/19iht-19perf.20294040.html (accessed November 14, 2011).

45. Christian Marclay, telephone conversation with the author, December 2, 2011.

46. George Michelsen Foy, *Zero Decibels: The Quest for Absolute Silence* (New York: Scribner, 2010), 71.

47. Amalia Pica, telephone conversation with the author, October 4, 2011.

48. André Malraux, *The Voices of Silence,* trans. Stuart Gilbert (New York: Doubleday, 1953), 639; 641–42.

A PROLONGED SILENCE
John Cage and Still After

Jenni Sorkin

While John Cage always made the claim that it was Robert Rauschenberg's White Paintings that prompted *4'33"*, also known as "the silent piece," there were other influences in the genealogy of its creation. The work was composed mostly during Cage's summer of 1952 at Black Mountain College, North Carolina, where he had been teaching alongside painter Franz Kline and poet Charles Olson.

First performed August 29, 1952, in Woodstock, New York, the silent piece is bracketed by three crucial moments, all occurring within a span of seven months: in June, Cage's famed event known as *Theater Piece #1* was performed at Black Mountain; in October, Black Mountain College held an international pottery seminar, where Buddhist thought was disseminated through workshops and lectures; and in December, Harold Rosenberg's seminal article "American Action Painters" was published in *ARTnews*. These occurrences were not coincidental: all can be traced through Black Mountain. With its roster of radical teachers and thinkers, such as Josef Albers, M. C. Richards, and Olson, the college became both conduit and catalyst for an emergent strain of avant-garde artistic production, including its Light Sound Movement Workshop that was active from 1949 to 1951.

Credited as the first-ever Happening in postwar art, *Theater Piece #1* also functioned as a reinvention of a late-nineteenth-century idea that lingered in avant-garde art and music: the Wagnerian *Gesamtkunstwerk*, a "total work of art" in which the melding of a plethora of art forms—dance, poetry, oral recitation, music, painting— serves as a conjoining process that restores freedom through unity. Richard Wagner saw the solitary art form as profoundly limited by its lack of integration. Or, as the art historian Juliet Koss describes it, "In joining the *Gesamt- kunstwerk*, each art form grew stronger in the struggle to define itself against the others and became more independent in the process. . . . The interrelation of the arts provided the necessary conditions for ensuring the autonomy of each."[1]

But the Happening also proved overwhelming to its audience, impeding the possibility of silent reflection. In this way, *4'33"* is its exact opposite, a composition during which, for the premiere, the pianist David Tudor closed the keyboard cover at the beginning, and then raised and reclosed it between movements, all while stationed silently at the keyboard for four minutes and thirty-three seconds.

The work exemplifies Cage's radical, and constantly evolving, aesthetic, effectively demonstrating that first, the artist has only to produce the conditions for artistic production to occur; second, all sound has the potential to be music; and finally, there is no actual silence, anywhere, at any time, since the sounds emanating from the concert audience *become* the performance itself. A tantalizing impossibility is offered: no fidelity to the score could ever exist, since the privileging of the audience displaces the centrality of the performer. Or, as Seth Kim-Cohen observes, "[Cage] sought to overturn the presumptions, habits and hierarchies that had set [classical] music's agenda for three hundred years."[2]

Tudor's original silence—and the silence of all subse- quent performers—abnegates the virtuosity of the concert pianist and forces the hand, so to speak, of the viewer, turning spectators into reluctant performers who watch

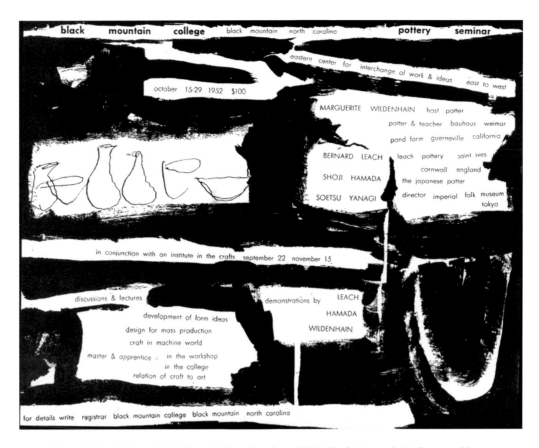

Flyer for Black Mountain College Pottery Seminar, 1952. Black Mountain College Archives, North Carolina State Archives, Raleigh

each other cough, sniffle, rustle, whisper, and giggle nervously. The audience is thus fragmented into an indecisive entity, torn between several binaries that oscillate not only by role:

> performer/viewer;
> spectator/spectacle; mediator/mediated;

but also action:

> stay/leave; watch/listen;
> presence/absence; complacent/collaborative.

Comprising three movements, and dependent upon the consultation of a timepiece, each version of *4'33"* is its own chance-inviting performance, authentically new and wholly contingent upon the environment and the audience's reaction: a different group witnessing itself reacting to the shock of prolonged silence and the eventual realization that

any "music" produced is the result of a dramatically altered subjectivity. Each subsequent presentation becomes a fresh endeavor, unable to be replicated. But while the original 1952 audience was unsuspecting, contemporary audiences have, by and large, come to anticipate the self-reflexive aural nature of the event. This expectation has, in turn, altered the legacy of *4'33"*, rendering it as a visual spectacle rather than an intensive listening experience. But such visuality is actually in keeping with the original context of the silent piece, which challenged the dominance of Abstract Expressionist painting, and paralleled the performative basis of Black Mountain's pottery seminar.

Late in life, Cage described the silent piece as being written "in the flush of my early contact with oriental philosophy."[3] Caroline Jones has effectively demonstrated Cage's centrality in challenging what she terms the "Abstract Expressionist ego," identifying his role as "Zen

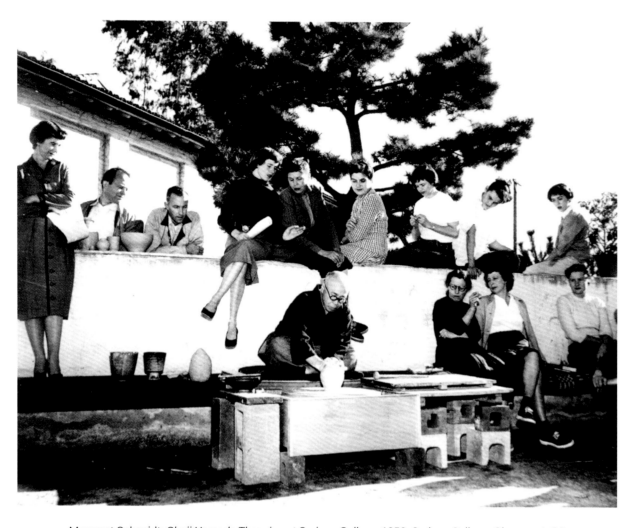

Margaret Schnaidt, *Shoji Hamada Throwing at Scripps College*, 1953. Scripps College, Claremont, CA

master" within two different camps: the Abstract Expressionists themselves, and the generation of 1960s process artists that came after, such as Robert Smithson and Robert Morris.[4]

In the 1950s, it seemed possible that Eastern thought had the ability to cure the West of its all-consuming belief in free will and individual subjectivity, in effect, to solve the problems inherent to Western modernity. Or, put another way, Zen had the potential to short-circuit Abstract Expressionism's abiding self-interest in the individual interlocutor. The mediation of art by the artist is rejected in favor of direct experience. In the silent piece, Cage frees the traditional concertgoing audience from its own captive silence, essentially encouraging noise in order to firmly reject the idea that any art form requires total reverence for the artist. This is a direct challenge to Abstract Expressionism's deep absorption with itself, both as a theatrical

medium and as a heroic artistic path. Cage's interest in empty spaces, vertical formats, nothingness, chance, unintentionality, the absence of the self, the uses of ambient sound, mindfulness, and states of awareness all point to an affinity with Buddhist philosophies, and their greater application in avant-garde artistic practice.

Yet on October 15, 1952, a mere six weeks after the silent piece was performed in upstate New York, two seemingly more authentic aesthetic "Zen masters" from Japan arrived at Black Mountain: Shoji Hamada, a Buddhist potter who threw at the wheel in utter silence, and his colleague Soetsu Yanagi, the founder of the Japanese *mingei,* or folk art, movement and founding director of the Japan Folk Craft Museum in Tokyo. Yanagi also had been a student of Daisetz T. Suzuki, the foremost Buddhist scholar working transnationally, who had a great deal of influence in the West as the source of most things Zen in 1950s America.[5]

Held for two weeks, the Black Mountain Pottery Seminar is one of the earliest instantiations of Buddhist-inflected philosophies being disseminated to American art students, most of whom were already professional potters and teachers elsewhere. The meditative quality of handwork combined with the rhythmic rotation of the potter's wheel possessed a powerful affect, connected to the essence of Zen contemplation—to be "at one" with the clay, where the hands' actions become involuntary, or intuitive, and in tandem with the conscious mind. Such mind-body practices came to be idealized in the West as "Zen," a spiritual practice assumed to be the same thing as Zen Buddhism.

Indeed, Yanagi's writings were steeped in spirituality, and descend from a mix of Zen and Pure Land Buddhism, a practice rooted in spontaneity and compassion.[6] Or as Yanagi himself wrote, "as in religion, a real salvation is found in the field of craft—one finally finds real self-affirmation in the abandonment of self."[7] Yanagi's *mingei*, which privileged anonymity in craftwork and ownership, stood in bold opposition to the Western emphasis on individualism.

Similarly, Hamada became the touchstone for the performance-based sensibility that permeated American studio ceramics. Through the live pottery demonstration, Hamada restored the fleeting, experiential quality to a process—throwing at the wheel—that has the limitless potential to be authentically new each time. Such presentness had a shaman-like effect on the students, introducing a performativity previously unseen in American ceramics, which had become a perfunctory and maybe even rote exercise in object-making. Hamada invigorated his craft, raising the stakes for the next generation of practitioners, such as Peter Voulkos, who would also become performers of the medium.

Zen encapsulated movement and a modality of being defined not as a noun but rather as a verb, or what Suzuki called the "actional":

> The second disciplinary approach to the experience of enlightenment is actional. In a sense, verbalism is also actional as long as it is concrete and personal. But in the actional what we call "the body" according to our sense testimony, is involved.[8]

It might be more realistic to think of Cage as embodying an "American type" Zen, part of the Zeitgeist that swept the avant-garde throughout the 1950s, permeating nearly all facets of cultural production including Beat literature, atonal music, Abstract Expressionist painting, and modern-ist pottery. Zen was not just content, it was also an aesthetic style that conveyed immediacy, as in the calligraphic brushwork of Kline and Adolph Gottlieb.

Such a "Zen boom," as it has been called, has been attributed to a variety of sources, from nineteenth-century Chinese immigrant culture on the West Coast to Henry David Thoreau's Transcendentalism.[9] Cage himself had a strong interest in Thoreau's theology, and often lectured on it. Yet the scholarly representation of the Zen boom is now much more nuanced. The Buddhist scholar Robert Sharf calls this phenomenon an ideology of "free-floating Zen," in which Zen became an experiential entity rather than a complex Buddhist philosophy. As Sharf has argued, Zen is the only sect of Buddhism that was brought to the West, rather than "discovered" by it.[10]

Like Yanagi, Cage considered himself a student of Daisetz T. Suzuki, though he could probably be more correctly construed as a disciple. In 1950, at the age of eighty, Suzuki was invited by the Rockefeller Foundation to do a lecture tour of American universities, after which he settled at Columbia University in New York City, where he taught intermittently between 1952 and 1958, making himself available to seekers such as Cage. Other art world luminaries who attended Suzuki's lectures included Philip Guston, Ibram Lassaw, Ad Reinhardt, and Betty Parsons.[11]

Suzuki argued strenuously that Zen was not a philosophy but a practice in which consciousness structures experience, as opposed to the Western model of experience structuring consciousness. Suzuki described Zen as such: "Zen is discipline in Enlightenment (*satori*) . . . experience and expression are one."[12]

In Cage's silent piece, as in Hamada's silent Black Mountain pottery demonstrations, experience and expression were indeed merged: presence was embodied by the performance of a work of art *in process*, whether a composition or a vessel. Each embodied the continuous making of an open, or live, form before an audience. The indeterminacy present during the act of throwing forms on the pottery wheel is akin to the indeterminacy of the Cagean performance, and not unlike the Abstract Expressionist canvas, where thumb- or fingerprints (those of Jackson Pollock especially) sometimes appear, also registering the momentum of gesture.

In this way, the "actional" was crucial to the aims of Abstract Expressionism, first described by the critic Harold Rosenberg as "Action Painting," the canvas of which he proclaimed to be an event rather than a picture.[13] While

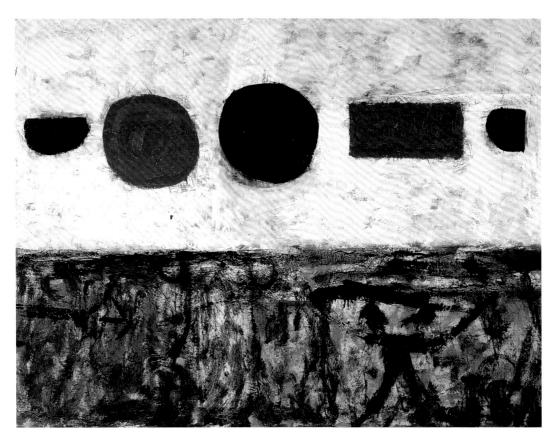

Adolph Gottlieb, *The Frozen Sounds, Number 1*, 1951. Oil on canvas, 36 x 48 inches.
Whitney Museum of American Art, New York, Gift of Mr. and Mrs. Samuel M. Kootz

Rosenberg was never at Black Mountain, many from his circle were: Kline, Willem de Kooning, Robert Motherwell, and Jack Tworkov. As Rosenberg declared, "The gesture on the canvas was a gesture of liberation, from Value—political, aesthetic, moral. . . . A far-off watcher unable to realize that these events were taking place in silence might have assumed they were being directed by a single voice."[14] Rosenberg's evocation of silence is striking: consciously or not, he conjures the image of Abstract Expressionism as itself a "silent piece"—a gesture on a stage, where a far-off watcher (from a future generation, perhaps) sees the performance as both freeing and singular.

Cage's silent piece is wholly determined by its own time and place. It is a work that reacts against the Abstract Expressionist privileging of the artist-as-mediator, only to be similarly dependent upon a parallel logic: a philosophy of chance, which becomes its own form of mediation, a structuring device present in nearly all of Cage's compositions and artworks from about 1952 onward. Moreover, Zen became a pervasive, even fashionable, ethic of awareness

to pursue in socially repressive 1950s America. Despite this, it is hard to overestimate Cage's influence in dislocating sound—rather than seen as a natural phenomenon, it becomes an oppositional aurality, or as Cage himself wrote, "Music is an oversimplification of the situation we are in. *An ear alone is not a being*."[15]

With its uncanny simplicity, *4'33"* resonates as a landmark work: a remaking of art-as-collective-experience, an origin moment for anti-object visuality, and the fullness of silence as a negation of individual autonomy. The silent piece has also become a point of departure for a host of works that thematize stillness, contemplation, and ambient noise.

Steve Roden engaged in a yearlong performance project in which he made a daily ritual of performing the Cage score. This solo act merged the performer and the audience into one, or, as Roden writes, "*4'33"* demands looking and, in fact, part of its strength as a performance comes from seeing the performer's actions, which shows the audience that the sounds we are hearing were not

Bruce Nauman, *Mapping the Studio I (Fat Chance John Cage)*, 2001.
7 video sources, 7 video players, 7 projectors, 7 pairs of speakers, and 7 log books,
color, sound, each video source 5 hr. 45 min. Collection Lannan Foundation,
long-term loan. Courtesy of Dia Art Foundation, New York

generated by the performer."[16] This is a reinforcement of the visual, underscoring that the success of the silent piece rests on its ability to create a visual frame for an aural experience. Yet Roden's own work privatized the experience, unmaking the collective in favor of the personal, almost devotional nature of falling silent for four minutes and thirty-three seconds each day. In a diary format, Roden documented this exercise as a means of exploring the conflicts between time and perception, while dabbling in mindfulness and introspection. Many of the earliest entries speak to the failure of his ability to focus or correctly time four minutes and thirty-three seconds—the misjudging and cerebral wanderings that overtook the performance, the intrusions and interruptions: distant cars (which are expressed, also in the spirit of Cage, in mesostics), crickets, the drone of electronics, and the crackling of Kleenex-stuffed ears. Roden's attempt to "hear beyond the silence" produced a generative and melodious text, one that

suffuses poetry with cryptic wanderings into sound as an exploration of time, synchronicity, and preoccupation. Absence and loss are concurrent themes, bracketed by the striking observation that "most silence is noticed after the sound has gone." Ultimately, Roden's piece is less a search for Cage's score than it is about finding the musicality in everyday living, in the comforting, familiar sounds such as the dog lapping water or the sound of walking barefoot upon sand.

Manon de Boer's film *Two Times 4'33"*, 2008, is another alteration of Cage's original score. Doubled, as it is performed twice, back to back, by a concert pianist seated in a private studio environment, the intervals come as movements marked by using a chess clock. First, the score is completed by the sounds of strong gusts of wind and a misty rain in the background, which can be glimpsed through the window behind the performer, who is absorbed in his timing. There is an audience present, but they are

off-camera. As viewers we are unaware of their presence until they clap profusely at the end of the performance. At the beginning of the first interval of the second performance, they come into view, visible through a slow pan. We are now conditioned to listen for them, and strain to hear their expected movements—rustling, scratching, fidgeting, even blinking. This time, total silence. Dropping all sound but the clock clicks from the movement, this is de Boer's trick. Such a purposeful editing out—a silencing—speaks to the dissonance of contemporary film and its technologies, in which the visual and the aural are reconnected only in the final editing process. This collapse, of listening and looking, is still capable of creating a credible narrative that as viewers we are habituated, some would say lulled, into following.

De Boer's viewer waits for something to disrupt the unflinching monotony, reminiscent of Bruce Nauman's video work *Mapping the Studio I (Fat Chance John Cage)*, 2001, in which the artist filmed the stillness of his studio through the course of a night and screens the resultant work in real time. Eventually, something does interject: the artist's cat, eyes glowing brightly, dashes across the screen, chasing what may be a mouse. De Boer's video embraces the same embodied perception, in which the only tangible moments of sound result in deferral—a displacement that sparks complex visual forms embedded in repetition, sequencing, and discontinuity.

Ultimately, Cage's silent piece functions as an inaugural moment in the history of postwar art—its active engagement of the audience is itself an aural work-in-progress that continues to provide an evolving confluence of sound, dissonance, and contact, highlighting the tensions that invariably exist between an audience, a performer, and a performance. From Cage's original provocation, new works will continue to be made, testing the limits of visuality, further expanding the communal repertoire: calibrating the weight of the piece historically, and its spirited lingering.

Notes

1. Juliet Koss, *Modernism after Wagner* (Minneapolis: University of Minnesota Press, 2010), 17.
2. Seth Kim-Cohen, *In the Blink of an Ear: Toward a Non-Cochlear Sonic Art* (New York: Continuum Books, 2009), 19.
3. John Cage, quoted in Stephen Montague, "John Cage at Seventy: An Interview," *American Music* 3:2 (Summer 1985): 213.
4. Caroline A. Jones, "Finishing School: John Cage and the Abstract Expressionist Ego," *Critical Inquiry* 19:4 (Summer 1993): 628–65.
5. Yuko Kikuchi, "The Myth of Yanagi's Originality: The Formation of 'Mingei' Theory in Its Social and Historical Context," *Journal of Design History* 7:4 (1994): 249–50.
6. Elizabeth Porcu, *Pure Land Buddhism in Modern Japanese Culture* (Leiden: Brill, 2008), 6; 150–52.
7. Soetsu Yanagi, *The Unknown Craftsman: A Japanese Insight into Beauty* (New York: Kodansha International, 1972), 223.
8. Daisetz T. Suzuki, *Zen and Japanese Culture* (1959; repr. Princeton, NJ: Princeton University Press, 1993), 5.
9. Rick Fields, *How the Swans Came to the Lake: A Narrative History of Buddhism in America* (Boston: Shambhala, 1981), 205.
10. Robert H. Sharf, "The Zen of Japanese Nationalism," in *Curators of the Buddha: The Study of Buddhism under Colonialism*, ed. Donald S. Lopez, Jr. (Chicago and London: The University of Chicago Press, 1995), 108.
11. Helen Westgeest, *Zen in the Fifties: Interaction Between East and West* (Zwolle, The Netherlands: Wanders Uitgevers, 1996), 52.
12. Suzuki, *Zen and Japanese Culture*, 8.
13. Harold Rosenberg, "American Action Painters," *ARTnews* 51:8 (December 1952): 22–24, 48–50.
14. Rosenberg, "American Action Painters," 24.
15. John Cage, "45' for a Speaker" (1954), in *Silence: Lectures and Writings* (Middletown, CT: Wesleyan University Press, 1961), 149.
16. Steve Roden, *365 x 433*, 2011, four books of text.

THE SOUNDS OF SILENCE
Some Thoughts on Silence in Experimental Film and Video Practice

Steve Seid

There is no such thing as silence. Something is always happening that makes a sound.

—John Cage, "45' for a Speaker" (1954)[1]

Silence hasn't been a simple thing since John Cage presented his noise-canceling composition *4'33"* in 1952.[2] What was once thought of as the zero dB default of sound was now a subset, rife with durational artifacts, ringings and decayings, and soft exhalations from the void. Cage came to understand in a perhaps Heisenbergian manner that even to observe silence was to alter it—the body's arterial rush roiling the hush.[3] No absolute here: silence was a thing of infinite variety and chance intrusion.

Film artists, on the other hand, knew a different silence. They were born into it, only to see silence surpassed by sound. And if sound served the artist's intent, it was to muffle the mechanism, the film apparatus, that obscured the image beneath its roar. Sound in cinema, as we shall see, emerged as an accomplice in a historical effort to create uncontested simulations of life. This was the primal pursuit of a realism that chained the image to its logical sound, rendering both as assuredly accurate. It mattered little that the film medium had its own properties to enjoy: the photochemical substrate, framed and advanced, a time-based canvas for poetic issuance. And within each frame, a small space reserved for the dense striations of sound, to be used or not.[4]

Within the film arts, sound or silence often served the same intent: to focus the senses on the unfolding image.

The Sounds of Silence is a three-part screening series of experimental films and video works dating back to 1936. This essay concentrates on part one, "A Kind of Hush," which examines the aesthetic placement of silence within an avant-garde practice. The other two programs, "Sonic Slippage" and "Sourcing Sound," emphasize sound as a subversive tool in an effort to realize a more poetic manifestation of the moving image.

Here, we trace the origins of silence in a mute medium, then travel beyond to the sound barrier.

The silent film period was anything but. It was rare that silence filled the auditorium; rather, it was nudged aside by a din of anarchic sounds and mixed intentions. Often shown in a vaudevillian context, cinema of the pre-sound era was typically accompanied by two-bit piano players, shrill phonographs, stentorian narrators, or the boozed-up voices of the audience itself. Film directors resented this unintended accompaniment not for its rude outbursts but for the way in which the autonomy of a film's experience was misdirected by the ruckus. The issue of a film's silence was of little concern—more to the point were the intentions of the sounds that would mask it.[5]

While aesthetic control over theatrical exhibition slowly consolidated, the film industry promoted countless inventions that synchronized sound and image at the moment of their delivery. Most were inadequate due to primitive amplification and recording quality, but as early as 1895 Edison's Kinetophone, a peep-show player, offered simultaneous sound for dance and band shorts. Throughout the silent era, sound devices—variants on the phonograph—

were mechanically linked to the projector and, in rarer instances, advances placed the sound source on the film strip itself. The Vitaphone, an accurate method of syncing recorded sound to film via shellac discs, was used for the first feature-length "talkie," *The Jazz Singer,* 1927, nudging the inevitable forward. Soon superior sound-on-film technology was embraced, and in 1928 an industry-wide standard formally bid farewell to the silent film era.

So why this compressed history of cinema's earlier years?

Any discussion of sound and cinema, especially one privileging silence itself, must take into account a historical tendency toward more refined forms of representational verisimilitude. The long-term pursuit of realistic renderings of the world—from Renaissance perspective to 3-D cinema—is often at odds with the short-term exigencies of a particular medium. The formation of the "silent film aesthetic" is an example of an inspired response to the intrinsic limitations of an image-making apparatus.

Given the absence of film sound, the visual expressivity of early cinema was developed to accentuate photographic composition and organic editing techniques in the service of new forms of time-based narrative. This cinema was quasi-poetic, as the image was involuntarily divorced from its referential linkage to a world of sonorities, one that would have audible dialogue emitted from gesticulating mouths, the rustling of leaves in visible trees, the creak of doors in dusky hallways. Here a slippage occurred between the moving image and the thing signified. Unadorned reality would stand outside the poeticized image, alienated and mute, but humbled somewhat by the orchestral workings that usually filled the auditorium.

While the silent film aesthetic developed in a kind of dazzling innocence, elsewhere lab technicians conspired to wed sound to the pictorial medium and do away with these charmed discoveries. Ironically, the introduction of sound technology also allowed for the creation of the first "'true' silent film," as Fred Camper noted in his seminal essay on sound and nonnarrative cinema, a cinema more abstract and painterly than preoccupied with plot.[6]

This necessarily avant-garde cinema encouraged the deployment of silence as an aesthetic choice rather than a default of the medium's lack. The practice that arose thrived in a dual negation that was a response to a techno-logical imperative (the subversion of the evolving appara-tus) and a resistance to an industrial tendency to view film as a medium whose consummation was in an ever-perfecting verisimilitude.

If we were to source this negation, we would locate its more public production in the European avant-garde of the mid-1920s. This was the Dada-drenched cinema of Marcel Duchamp, Fernand Léger, Man Ray, René Clair, Jean Cocteau, Germaine Dulac, Luis Buñuel, and Salvador Dalí. It was a cinema of delightfully obscure montage and provocative intention, accompanied by the boisterous orchestrations of such composers as Erik Satie and George Antheil.

The American contingent was slower to emerge, its ranks filled by such luminaries as Oskar Fischinger, Paul Strand, James Sibley Watson, Robert Florey, and others, but this countermovement that flowered in the 1940s has pullulated unabated to the present.

While Hollywood-inspired cinema emphasized the refinement of storytelling with a de facto dependence on the accurate image, the emerging American avant-garde drew inspiration from the materials themselves and tore the image from its roots in reality. Narrative was seen not as an indigenous characteristic of the film medium but a nonnative transplant from an older literary tradition. What was inherent perhaps was the durational succession of frames (to be filled up or emptied out), borne upon a shaft of light—nothing more, nothing less. Even sound was optional, as that precious space reserved for it within each frame could be left untouched or the projector's exciter lamp turned off.[7]

Silence, as far as the medium was concerned, was an absolute potential, though not as simple as no-sound, as we shall see.

As to be expected, the ranks of the avant-garde cinema were split between subversive sonority and those that dwelt in silence. Two early tendencies in sound can be found in the stunning visual montage of Oskar Fischinger, whose abstract geometric compositions of the 1930s and '40s were choreographed to jazz and classical music, and Joseph Cornell's cacophonous *Rose Hobart,* 1936, in which "tropical" songs dislodge the image track from its source in the appropriated feature *East of Borneo*. These two uses of sound, one of unification, one of alienation, continue as viable strategies for a more poetic and personal cinema.

To seek early uses of elemental silence one need go no further than the hallucinatory reverie of Maya Deren's *Meshes of the Afternoon* of 1943. Co-directed with Deren's husband, Alexander Hammid, *Meshes of the Afternoon* is a dreamlike narrative that thrives on circularity. A cloaked figure stalks a woman whose attempts at flight are frus-

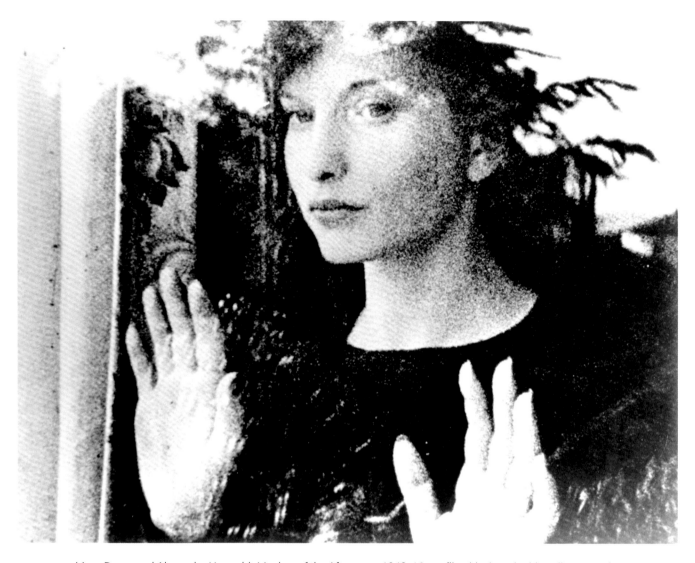

Maya Deren and Alexander Hammid, *Meshes of the Afternoon*, 1943. 16mm film, black-and-white, silent, 14 min. The Museum of Modern Art, New York. Courtesy of Tavia Ito, executor of the Maya Deren Estate

trated by the confining and off-kilter walls of her abode. A repeated series of iconic images—a falling key, a knife in a loaf of bread, a flower lying on the driveway—replicates the sense of entrapment. The silence that enshrouds *Meshes* is not a theorized silence, it is the silence of omission, the residue left behind when sound is ignored. Yet it serves the film well, focusing the audience's attention while adding the latent dread that only silence can provoke.[8] Deren's considered silence also heightens the sense of psychological suspension necessary to the dream-state of the film. Though music might serve to accent the tacit terror or enforce the circularity through repetitive themes, it would also impose its own time signature on the surreal proceedings and set it on a linear course.

Ironically, the silence of *Meshes of the Afternoon* turned out to be temporary, for it was replaced in 1959 by a delicately inflected score composed by Deren's third husband, Teiji Ito.

Deren's sense of silence was in a way a relic of the silent era, tempered by her strong interest in the French Surrealists. Within a few years, silence would be pregnant with meaning as cinema revealed what Nathaniel Dorsky called its "open mystery" through a single sense reception.[9] This was a complicated silence that demanded a new attentiveness. "Without sound to spatialize it directly," writes Camper, "the image, whatever its content, hovers before the viewer in a kind of mysterious and splendid isolation, like a fragile chimera."[10] However, this isolation was forever imperfect

Stan Brakhage, *The Riddle of the Lumen*, 1972. 16mm film, color, silent, 17 min.
Canyon Cinema, San Francisco. Courtesy of the Estate of Stan Brakhage

and punctured by the presence of the restive audience, just like those who sat in the ruminating silence of *4'33"*.

An acknowledged master of the silent film, Stan Brakhage began his career in the early fifties, interspersing sound works along with silent ones. But it wasn't until *Anticipation of the Night,* 1958, that he issued his first "intentionally silent film."[11] The revelations needed to conceive of silence as a pliable medium itself came from his informal study of composers Edgard Varèse and, particularly, John Cage, who had already debuted *4'33"*.[12] But much of Brakhage's exploration of silence lay not in the void of quietude before the screen but in what he called "the silent sound sense," "associational sounds" that reside in the mind and are coaxed to recognition by rhythms, patterns, and other visual orchestrations.[13] "I seek to hear color," said Brakhage, "just as Messiaen seeks to see sounds."[14] It would take a teeming silence for his color to transmogrify as sound.

In 1972, Brakhage set out to make a film that would be the equivalent of a riddle, but one in which the punning disclosures would be purely visual. *The Riddle of the Lumen*, an "open-form, or polyvalent, film" as P. Adams Sitney would call it, challenges the connective tissue between shots.[15] Using scraps of luminous footage he had shot for earlier projects, Brakhage pieced together a montage joined not by composition or the internal logic of tempo but by the qualities of light, radiance joined to radiance. "'The hero' of the film is light/itself"—the

Nam June Paik with *Zen for Film*, 1962–64.
Photograph by Peter Moore. Courtesy of the Estate of Peter Moore

photonic protagonist.[16] Unlike, say, Nam June Paik's *Zen for Film*, 1962–64, in which the artist created a rectangle of pure light using clear film leader and then waited for deterioration to deposit a Cagean image, Brakhage sought out the luminous linkages in already profuse images. In this case, silence was the clear leader through which unhindered luminosity might flow.

"The profundity of sitting quietly" is only the first step in engaging the silent films of Nathaniel Dorsky.[17] His body of work, poised ever serenely atop a Buddhist practice, contains a silence with great purpose. Projected at silent speed,[18] Dorsky's timorous images emerge slowly, ripening gradually within the mind's eye. Based on a honed precision with the captured image, his films address "the mystery of presence" through the astute observation of the material world.[19] Sound, he insists, "brings your metabolism to the screen"—it activates the corporeal.[20] In Dorsky's films, the silence is one of fullness without the body quickened.

A "devotional song" to the late Brakhage, Dorsky's *Threnody*, 2004, laments the elder filmmaker's passing through an intuitively assembled montage of mournfully toned images. Elusive yet brimming, the individual shots are separated by "tender" intrusions, and in their delicately weighted transit "mystery, suggestiveness, intriguing indiscernibility, or even sheer beauty might be marshaled."[21] A toppled statue in a shopwindow, trees burdened by a sudden snow, a scribe writing down notes in a journal—disparate images that speak across the void of

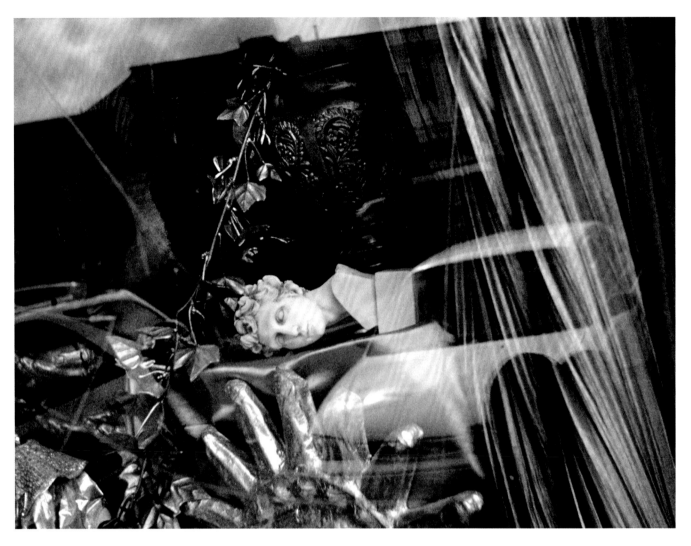

Nathaniel Dorsky, *Threnody*, 2004. 16mm film, 18 fps, color, silent, 25 min.
Canyon Cinema, San Francisco. Courtesy of the artist

sorrow with each edit a held sob. Here, the magisterial silence is that stillness at the threshold of life.

A Conceptual artist grounded in sound practice, Steve Roden created a stark form of ambient Minimalism called "lowercase." The defining example of the movement, the 54-minute *forms of paper*, 2001, interrupts stretches of silence with heavily amplified micro-sounds of paper rustling.[22] This is an inverted Cagean strategy in which the artist mines that hushed micro-zone of barely perceptible sound, rather than having sound emerge of its own volition from silence. Roden's investigations of different analogous manifestations of sound have been reified within many mediums, film and video work being among them.

A homage to his grandmother, Roden's *four words for four hands (apples.mountains.over.frozen.)*, 2006, has at its core a twelve-page music score that, as a child, he had discovered in his grandmother's home. While handling the score, he realized the musical staff fit within the dimensions of a 16mm film frame. He then set about tracing the musical notation directly onto clear leader, using a set of colored pens, a different color for each of the six notes. When printed, the length of the film was altered to correspond to the approximate playing time of the score. Through this animated process of transliteration, the notational system of music is visualized, then set loose in a stream of tinted pulsations. In Roden's speckled work, the eye is put in the service of the ear, consummating in a way Brakhage's desire to "hear color."

In a 1928 essay titled "Problems of the Modern Film," László Moholy-Nagy, an artist and professor at the Bauhaus, argued that the sound film was ignoring its full sonic potential. "To develop creative possibilities of the sound film," he wrote, "the acoustic alphabet of sound writing will have to be mastered; in other words, we must learn to write acoustic sequences on the sound track without having to record real sound."[23] Taking this to heart, "film-painter" Barry Spinello would perfect an "acoustic alphabet" of his own during a rich exploratory period in 1969. Spinello was also interested in ideas developed by Cage in the late thirties: "Cage speaks of a 'new electronic music' to be developed completely out of the photo-electric cell optical sound machinery of film."[24] In this sense, the projector's exciter lamp reading sonic densities off the passing film becomes the unwitting instrument for a brand of *musique concrète*, cinema-style.

Spinello's resulting *Soundtrack*, 1969, is sonic in the way that Roden's *four words for four hands (apples. mountains.over.frozen.)* is silent; both rely on handwrought gestures that are transmuted from one representational system to another. *Soundtrack* plies two distinct "alphabets," one composed of dots and lines rendered with a drafting pen, the other using premanufactured screen patterns and drafting tapes. Both acoustic systems are rendered by hand over the soundtrack, frame by frame, the pitch controlled by shape and size, the rhythm by spacing. "The carefully composed and modulated sound-painting" was then redrawn on the image track so that the viewer "sees what he hears."[25] *Soundtrack*'s staccato score, with its angular, lockstep rhythms, is reinforced by the wed patterns of the image track. A degree of synesthesia is conjured as the mutually reinforcing tracks unify the reception by eye and ear.

Steve Roden, *four words for four hands (apples.mountains.over.frozen.)*, 2006.
16mm film transferred to video, color, silent, 17 min.
Courtesy of Susanne Vielmetter Los Angeles Projects and CRG Gallery, New York

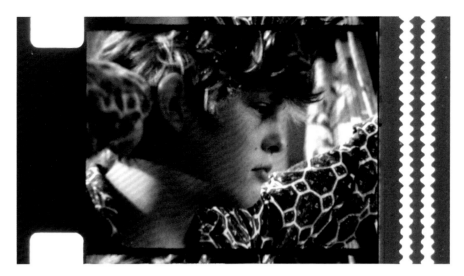

Optical soundtrack on the right edge of frame from the 16mm film *Day Off*.
Courtesy of Films4Ever, Bit Works, Inc., Thornhill, Ontario

Barry Spinello, *Soundtrack*, 1969 (detail). 16mm film, color and black-and-white, sound, 10 min.
Canyon Cinema, San Francisco

That master of quietude, Stan Brakhage had written in the mid-sixties, "I now see/feel no more absolute necessity for a sound track than a painter feels the need to exhibit a painting with a recorded musical background."[26] By placing his "sound-painting" over the optical track, Barry Spinello could have it both ways.

No, silence hasn't been simple since John Cage presented his gloriously gagged *4'33"* in 1952. One second later, at the mark of four minutes and thirty-four seconds, the unsuspecting listener discovered a new and untamed silence had been forever unleashed in the wild reaches of aurality. Silence had become an unruly subject, liable to bide its time in chance operation or granular eruption.

In its seeming emptiness, silence cannot be contained, "nor can silence, in its literal state, exist as the property of an artwork," stated Susan Sontag in her grand essay "The Aesthetics of Silence."[27] When related to an avant-garde moving image practice, the artist's ownership of silence might be realized imperfectly at the time of a work's creation, but rarely does that ownership survive the moment of reception. The brilliant rectangle of light wavers before the adulterated silence of the theater with its creak of seats unsprung, wheezing ventilation, pleuritic hum of lung, and nimble fingers texting, perhaps even the flapping film strip faltering in the projector's gate.

As indefinable as a borderless gulf, silence can swallow the best of intentions.

Notes

1. John Cage, "45' for a Speaker," in *Silence: Lectures and Writings* (Middletown, CT: Wesleyan University Press, 1961), 191.

2. Performed for the first time on August 29, 1952, at the Maverick Concert Hall in Woodstock, NY, David Tudor, piano.

3. For a spirited discussion of this point revealed to Cage in an anechoic chamber, see Kyle Gann, "The Anechoic Chamber," in *No Such Thing as Silence: John Cage's 4'33"* (New Haven, CT: Yale University Press, 2010), 160–66.

4. The original theatrical format, 35mm, was introduced in 1892 and had two sets of perforations to carry the film stock through the projector. With the advent of sound in the late 1920s, a small space was set aside between the perforations and the image to print an optical audio track. Introduced in 1923, the 16mm film format also had dual perforations to pull it through the projector. With the advent of sound, the space along the image that would otherwise be reserved for the second set of perforations was replaced by the optical track. 16mm was thought to be an amateur format, but because of its lesser cost was quickly adopted by film artists.

5. These comments are inspired by the groundbreaking research of Rick Altman and his book *Silent Film Sound* (New York: Columbia University Press, 2004), particularly a short chapter titled "Silencing the Film Audience."

6. Fred Camper, "Sound and Silence in Narrative and Nonnarrative Cinema," in *Film Sound: Theory and Practice*, ed. Elisabeth Weis and John Belton (New York: Columbia University Press, 1985), 370.

7. The exciter lamp passes light through the optical soundtrack of the film and saturates a photoelectric cell, causing current fluctuations that are amplified, then sent to the loudspeakers.

8. Theodor Adorno observed that film audiences confronted by profound silence developed visible anxiety. He coined the term *Horspielstreifen* to describe the subtle noise inserted in a film's soundtrack "whose purpose it is to subliminally confirm the presence of a reproduction under way, thereby establishing the minimum existence of some type of presence." Douglas Kahn, "Surface Noise on the DeMarinis Effect," Apollo Records CD booklet text (1995).

9. Nathaniel Dorsky, interview with the author, San Francisco, September 2011.

10. Camper, "Sound and Silence," 372.

11. Stan Brakhage, "Film and Music" (1966), in *Essential Brakhage: Selected Writings on Filmmaking*, ed. Bruce R. McPherson (Kingston, NY: Documentext, 2001), 79.

12. It's interesting to note that Brakhage released *Interim* in 1952 with music by James Tenney and *In Between* in 1955 with music by Cage, aligning himself with avant-garde New York composers.

13. Stan Brakhage, "The Silent Sound Sense," *Film Culture* 21 (Summer 1960): 66.

14. Brakhage, "Film and Music," 81.

15. P. Adams Sitney, "Tone Poems," *Artforum* 48: 3 (November 2007): 340–47, 400.

16. Stan Brakhage, "Film Annotations," in *Essential Brakhage*, 223.

17. Dorsky, interview with author.

18. Dorsky uses a 16mm projector at 18 frames per second (fps). Projection speed was variable throughout the silent era, ranging from 16 fps to 20 fps. To standardize sound film and give the audio track better dynamic range, projection speed was increased to 24 fps. Very few 16mm projectors were made with adjustable projection speed, and those that still survive are rare.

19. Dorsky, interview with author.

20. Dorsky, interview with author.

21. Sitney, "Tone Poems," 8.

22. CD published by LINE imprint (2001).

23. László Moholy-Nagy, "Problems of the Modern Film," revised and reprinted in *Vision in Motion* (Chicago: Paul Theobald, 1947), 277.

24. Spinello is loosely referring to John Cage's 1937 text "The Future of Music: Credo," reprinted in *Silence*, 3–6. Barry Spinello, "Letter from Oakland" (1969), in *Canyon Cinema*, ed. Scott McDonald (Berkeley, CA: University of California Press, 2008), 123.

25. Spinello, "Letter," 124.

26. Brakhage, "Film and Music," 79.

27. Susan Sontag, "The Aesthetics of Silence" (1967), in *Styles of Radical Will* (London: Vintage Press, 1969), 9–10.

FILM PROGRAM
The Sounds of Silence

Barry Spinello, *Soundtrack*, 1969. 16mm film, color and black-and-white, sound, 10 min. Canyon Cinema, San Francisco

Maya Deren and Alexander Hammid, *Meshes of the Afternoon*, 1943. 16mm film, black-and-white, silent, 14 min. The Museum of Modern Art, New York. Courtesy of Tavia Ito, executor of the Maya Deren Estate

Stan Brakhage, *The Riddle of the Lumen*, 1972. 16mm film, color, silent, 17 min. Canyon Cinema, San Francisco. Courtesy of the Estate of Stan Brakhage and Fred Camper

Nathaniel Dorsky, *Threnody*, 2004. 16mm film, 18 fps, color, silent, 25 min. Canyon Cinema, San Francisco. Courtesy of the artist

Steve Roden, *four words for four hands (apples.mountains.over.frozen.)*, 2006. 16mm film transferred to video, color, silent, 17 min. Courtesy of Susanne Vielmetter Los Angeles Projects and CRG Gallery, New York

A KIND OF HUSH

Maya Deren and Alexander Hammid
Meshes of the Afternoon, 1943
16mm film, black-and-white,
silent, 14 min.
The Museum of Modern Art, New York

Stan Brakhage
The Riddle of the Lumen, 1972
16mm film, color, silent, 17 min.
Canyon Cinema, San Francisco

Nam June Paik
Zen for Film, 1962–64
16mm film, color, silent, 8 min.
Nam June Paik Estate

Nathaniel Dorsky
Threnody, 2004
16mm film, 18 fps, color, silent, 25 min.
Canyon Cinema, San Francisco
Collection of the artist

Steve Roden
*four words for four hands (apples.
mountains.over.frozen.)*, 2006
16mm film transferred to video,
color, silent, 17 min.
Susanne Vielmetter Los Angeles Projects

Barry Spinello
Soundtrack, 1969
16mm film, color and black-and-white,
sound, 10 min.
Canyon Cinema, San Francisco

TOTAL RUN TIME: 91 MINUTES

SONIC SLIPPAGE

Rebecca Baron and Douglas Goodwin
Lossless #2, 2008
Video, black-and-white, sound, 3 min.
Video Data Bank, Chicago

Joseph Cornell
Rose Hobart, 1936
16mm film, 16 fps, tinted black-and-white,
sound on cassette, 19 min.
The Museum of Modern Art, New York

Harry Smith
Film No. 3: Interwoven, 1947–49
16mm film, color, sound, 3 min. 20 sec.
The Film-Makers' Cooperative, New York

Bruce Conner
Looking for Mushrooms, 1967
16mm film, color, sound, 4 min.
Canyon Cinema, San Francisco

Steina
Lilith, 1987
Video, color, sound, 9 min. 15 sec.
Electronic Arts Intermix, New York

Bruce Conner
Looking for Mushrooms, 1996
16mm film, color, sound, 14 min.
Canyon Cinema, San Francisco

Scott Stark
Driven, 2005
Video, color, sound, 8 min. 10 sec.
Collection of the artist

Peggy Ahwesh
She Puppet, 2001
Video, color, sound, 15 min.
Video Data Bank, Chicago

TOTAL RUN TIME: 76 MINUTES

SOURCING SOUND

Warner Jepson
Self-Portrait, 1975 (6 min. excerpt)
Video, color, sound, 45 min.
University of California, Berkeley Art
Museum and Pacific Film Archive

Robert Russett
Primary Stimulus, 1977
16mm film, black-and-white,
sound, 13 min.
Academy Film Archive, Los Angeles

Scott Wolniak
Flash Art (Circles and Rectangles), 2010
Video, color, sound, 5 min. 13 sec.
Video Data Bank, Chicago

Rudy Lemcke
Lightning Field, 2003
Video, black-and-white, sound,
2 min. 30 sec.
Collection of the artist

Van McElwee
Radio Island, 1997
Video, color, sound, 11 min. 40 sec.
Collection of the artist

Stephen Vitiello
Light Reading(s): Visual Mix, 2003
Video, color, sound, 10 min. 44 sec.
Collection of the artist

Darrin Martin
Monograph in Stereo, 2004–5
Video, color, sound, 17 min. 20 sec.
Collection of the artist

Rudy Lemcke
Waterlilies, 2003
Video, black-and-white, sound,
4 min. 4 sec.
Collection of the artist

Semiconductor
Brilliant Noise, 2006
Video, black-and-white, sound,
5 min. 47 sec.
Video Data Bank, Chicago

TOTAL RUN TIME: 76 MINUTES

ARTISTS IN THE EXHIBITION

JOSEPH BEUYS
b. 1921, Krefeld, Germany; d. 1986, Düsseldorf

In 1952, Beuys graduated from the Kunstakademie Düsseldorf, where he served as professor of sculpture from 1961–72. During the late 1960s and early 1970s, he was involved in the foundation of several activist groups, including the German Student Party, Organization for Direct Democracy by Referendum, and Free International University. The only major retrospective exhibition of Beuys's work during his lifetime opened at the Solomon R. Guggenheim Museum, New York City, in 1979. Recent solo exhibitions include *Joseph Beuys: The Multiples*, Los Angeles County Museum of Art (2009); *Beuys: Die Revolution sind wir*, Hamburger Bahnhof, Museum für Gegenwart, Berlin (2008); *Joseph Beuys: Actions, Vitrines, Environments*, The Menil Collection, Houston (2004); and *Joseph Beuys*, Bonnefantenmuseum Maastricht, The Netherlands (2001). Among the numerous group exhibitions of Beuys's work are *A Shot in the Dark*, Walker Art Center, Minneapolis (2010); *The Modern Myth: Drawing Mythologies in Modern Times*, The Museum of Modern Art, New York City (2010); *Art of Two Germanys/Cold War Cultures*, Los Angeles County Museum of Art (2009); *Eating the Universe*, Kunsthalle Düsseldorf (2009); and *All in the Present Must Be Transformed*, Peggy Guggenheim Collection, Venice (2007). He represented Germany at the 37th Venice Biennale (1976) and exhibited work at Documenta 4, 5, and 7 in Kassel, Germany (1964, 1972, 1982).

MARCEL BROODTHAERS
b. 1924, Brussels; d. 1976, Cologne

Broodthaers, who began his career as a Surrealist poet, is perhaps best known for the Musée d'Art Moderne, Département des Aigles, a fictitious museum he founded in 1968. He used it to organize exhibitions, produce publications, and screen films. Recent solo exhibitions of his work include *Von realer Gegenwart: Marcel Broodthaers heute*, Kunsthalle Düsseldorf (2010); *Marcel Broodthaers: Un Jardin d'Hiver . . .*, Musée des Beaux-Arts de Nantes, France (2004); *Marcel Broodthaers: Texte et Photos*, SK Stiftung Kultur, Cologne (2003); and *Marcel Broodthaers*, Palais des Beaux-Arts, Brussels (2001). Group exhibitions include *Animism*, Museum van Hedendaagse Kunst Antwerpen (2010); *Silenzio: Una mostra da ascoltare*, Fondazione Sandretto Re Rebaudengo, Turin (2007); *Magritte and Contemporary Art: The Treachery of Images*, Los Angeles County Museum of Art (2007); and *Part Object Part Sculpture*, Wexner Center for the Arts, Columbus, OH (2005).

JOHN CAGE
b. 1912, Los Angeles; d. 1992, New York City

Cage was a pioneer of electro-acoustic, experimental, and chance music. He attended Pomona College in Claremont, CA, from 1928–30 before studying musical composition with Adolph Weiss and Henry Cowell in New York City and with Arnold Schoenberg at the University of Southern California in Los Angeles and University of California, Los Angeles. Cage taught at the Chicago School of Design (now the Institute of Design, Illinois Institute of Technology) from 1941–42; Black Mountain College, NC, in the summers of 1948 and 1952; and The New School for Social Research, New York City, from 1956–60. He was awarded a John Simon Guggenheim Memorial Foundation Fellowship (1949), became a member of the American Academy of Arts and Sciences (1978), and received an honorary doctorate from the California Institute of the Arts, Valencia (1986). Solo exhibitions of Cage's work include *Every Day Is a Good Day*, BALTIC Centre for Contemporary Art, Gateshead, UK (2010); *La anarquía del silencio: John Cage y el arte experimental*, Museu d'Art Contemporani de Barcelona (2009); *John Cage*, University of California, Berkeley Art Museum and Pacific Film Archive (2002); and *Rolywholyover: A Circus for Museum by John Cage*, Museum of Contemporary Art, Los Angeles (1993), which traveled to The Menil Collection, Houston. His work has been in numerous group exhibitions, such as *Hear It!*, Stedelijk Museum Amsterdam (2011); *Chance Aesthetics*, Kemper Art Museum, St. Louis (2009); *The Quick and the Dead*, Walker Art Center, Minneapolis (2009); *The Art of Participation: 1950 to Now*, San Francisco Museum of Modern Art (2008); *Between Thought and Sound: Graphic Notation in Contemporary Music*, The Kitchen, New York City (2007); *Singular Forms (Sometimes Repeated): Art from 1951 to the Present*, Solomon R. Guggenheim Museum, New York City (2004); and *Neo-Dada: Redefining Art, 1958–1962*, Contemporary Arts Museum Houston (1995).

THERESA HAK KYUNG CHA
b. 1951, Busan, Korea; d. 1982, New York City

Cha earned BAs in both art and comparative literature before receiving her MFA from the University of California, Berkeley in 1978. She also studied at the Centre d'Études Américaine du Cinema in Paris. Cha was awarded an artist's residency at the Nova Scotia College of Art and Design, Halifax; taught video art at Elizabeth Seton College, Yonkers, NY; and worked in the design department of The Metropolitan Museum of Art, New York City. From 1980 until her death in 1982, she was an editor and writer at Tanam Press. Solo exhibitions of Cha's work include *Theresa Hak Kyung Cha: Earth* and *The Dream of the Audience: Theresa Hak Kyung Cha (1951–1982)*, University of California, Berkeley Art Museum and Pacific Film Archive (2009, 2001); and *Other Things Seen, Other Things Heard*, Whitney Museum of American Art, New York City (1993). Her work has been in group exhibitions such as *The Third Mind: American Artists Contemplate Asia, 1860–1989*, Solomon R. Guggenheim Museum, New York City (2009); *WACK! Art and the Feminist Revolution*, The Geffen Contemporary at the Museum of Contemporary Art, Los Angeles (2007); and *Mistaken Identities*, Neues Museum Weserburg Bremen, Germany (1993).

MANON DE BOER
b. 1966, Kodaikanal, India

De Boer studied at the Academie van Beeldende Kunsten (now the Willem de Kooning Academie), Rotterdam, from 1985–90 and at the Rijksakademie van beeldende kunsten, Amsterdam, from 1990–92. Her solo exhibitions include *Manon de Boer*, Witte de With Center for Contemporary Art, Rotterdam (2008); and *The Time That Is Left*, Frankfurter Kunstverein (2008). De Boer has participated in group exhibitions such as *Several Silences*, The Renaissance Society at The University of Chicago (2009); and *Presto–Perfect Sound*, P.S.1 Contemporary Art Center, Long Island City, NY (2007); and her work was included in the 29th Bienal de São Paulo (2010), 6th Seoul International Biennale of Media Art (2010), 5th Berlin Biennale (2008), and 52nd Venice Biennale (2007). Her films have been screened at film festivals in Hong Kong, Marseille, Rotterdam, and Vienna. De Boer lives and works in Brussels.

GIORGIO DE CHIRICO
b. 1888, Volos, Greece; d. 1978, Rome

De Chirico studied art in Athens before attending the Königliche Akademie der Bildenden Künste München (now the Akademie der Bildenden Künste München) from 1906–9. After spending time in Italy, he moved to Paris in 1911, and his work was included in the Salon d'Automne (1912 and 1913) and Salon des Indépendants (1913 and 1914). De Chirico returned to Italy after World War I, where he mounted his first solo exhibition at the Casa d'Arte Bragaglia, Rome (1918), and participated in the Venice Biennale for the first time (1924). Recent solo exhibitions include *La natura secondo de Chirico*, Palazzo delle Esposizioni, Rome (2010); *Giorgio de Chirico: La Fabrique de rêves*, Musée d'Art Moderne de la Ville de Paris (2009); *Giorgio de Chirico and the Myth of Ariadne*, Philadelphia Museum of Art (2002); and *Giorgio de Chirico*, The Museum of Modern Art, New York City (1982). De Chirico's work has been in such recent group exhibitions as *Chaos and Classicism: Art in France, Italy, and Germany, 1918–1936*, Solomon R. Guggenheim Museum, New York City (2010); *Italics:*

Italian Art between Tradition and Revolution 1968–2008, Museum of Contemporary Art Chicago (2009); *Subversive Spaces: Surrealism and Contemporary Art*, The Whitworth Art Gallery, University of Manchester (2009); *Surrealism: Desire Unbound*, Tate Modern, London (2001); and *Painters in Paris, 1895–1950*, The Metropolitan Museum of Art, New York City (2000). De Chirico's work was also included in the 38th and 46th Venice Biennales (1978, 1995), and in Documenta 1, 2, and 3 (1955, 1959, 1964).

MARCEL DUCHAMP
b. 1887, Blainville-Crevon, France;
d. 1968, Neuilly-sur-Seine, France

Duchamp is most often associated with the Dada and Surrealist art movements. He studied art at the Académie Julian, Paris, from 1904–5, before serving compulsory military service. Duchamp's early work was exhibited at the Salon d'Automne (1908) and the Salon des Indépendants (1909), both in Paris. His work was introduced to the American art scene with his submission of the controversial *Nude Descending a Staircase, No. 2*, 1912, to the Armory Show in New York City (1913). Duchamp began working with readymades in 1914, just before emigrating to New York. His infamous readymade urinal, *Fountain*, 1917, caused an uproar when it was submitted to (and rejected from) a Society of Independent Artists exhibition. There have been major retrospective exhibitions of Duchamp's work at the Philadelphia Museum of Art; The Museum of Modern Art, New York City; and the Pasadena Art Museum (now the Norton Simon Museum of Art), CA. More recent solo exhibitions include *Marcel Duchamp*, Moderna Museet, Malmö, Sweden (2011); *Marcel Duchamp Redux*, Norton Simon Museum of Art, Pasadena, CA (2008); and *Marcel Duchamp: Dustballs and Readymades Etc.*, National Gallery of Canada, Ottawa (1997). Group exhibitions include *On Line: Drawing Through the Twentieth Century*, The Museum of Modern Art, New York City (2010); *Chance Aesthetics*, Kemper Art Museum, St. Louis (2009); *The Quick and the Dead*, Walker Art Center, Minneapolis (2009); *Dada*, National Gallery of Art, Washington, DC (2006); and *Surrealism: Desire Unbound*, The Metropolitan Museum of Art, New York City (2002).

MICHAEL ELMGREEN
b. 1961, Copenhagen
INGAR DRAGSET
b. 1968, Trondheim, Norway

Elmgreen & Dragset have worked as a collaborative team since the mid-1990s. They were awarded special mention when they represented Denmark at the 53rd Venice Biennale (2009) and received the Preis der Nationalgalerie für Junge Kunst at the Hamburger Bahnhof, Museum für Gegenwart, Berlin (2003). Solo exhibitions of their work include *Celebrity: The One and the Many*, Zentrum für Kunst und Medientechnologie

Karlsruhe, Germany (2010); *Trying to Remember What We Once Wanted to Forget*, Museo de Arte Contemporáneo de Castilla y León, Spain (2009); *This Is the First Day of My Life*, Malmö Konsthall, Sweden (2007); *The Welfare Show*, Serpentine Gallery, London (2006); and *Blocking the View*, Tate Modern, London (2004). They had work in the 12th International Istanbul Biennial and 4th Moscow Biennale of Contemporary Art (both 2011). Other group exhibitions include *Exhibition, Exhibition*, Castello di Rivoli, Museo d'Arte Contemporanea, Turin (2010); *Lost and Found: Queerying the Archive,* Kunsthallen Nikolaj, Copenhagen (2009); *Mapping the Self*, Museum of Contemporary Art Chicago (2007); and *Into Me/Out of Me*, P.S.1 Contemporary Art Center, Long Island City, NY (2006). Elmgreen & Dragset live and work in Berlin.

DAVID HAMMONS
b. 1943, Springfield, IL

Hammons studied at the Chouinard Art Institute (now the California Institute of the Arts), Valencia, from 1966–68 and the Los Angeles Art Institute (now the Otis College of Art and Design), Los Angeles, from 1968–72. He is a recipient of a John D. and Catherine T. MacArthur Foundation Fellowship (1991) and was awarded the Rome Prize for visual arts (1990). Hammons's solo exhibitions include *David Hammons: Phat Free*, Fabric Workshop and Museum, Philadelphia (2004); *David Hammons: Antipodes 1*, White Cube, London (2002); and *David Hammons: Rousing the Rubble*, P.S.1 Contemporary Art Center, Long Island City, NY (1991). He has participated in group exhibitions such as *Investigations of a Dog*, Magasin 3 Stockholm Konsthall (2011); *Sound & Vision*, The Art Institute of Chicago (2010); *30 Seconds Off an Inch*, The Studio Museum in Harlem, New York City (2009); *NeoHooDoo: Art for a Forgotten Faith*, The Menil Collection, Houston (2008); *Multiplex: Directions in Art, 1970 to Now*, The Museum of Modern Art, New York City (2007); *Los Angeles, 1955–1985: Naissance d'une capitale artistique*, Centre Georges Pompidou, Musée National d'Art Moderne, Paris (2006); *Double Consciousness: Black Conceptual Art Since 1970*, Contemporary Arts Museum Houston (2005); and *Bottle: Contemporary Art and Vernacular Tradition*, The Aldrich Contemporary Art Museum, Ridgefield, CT (2004). Hammons lives and works in New York City.

TEHCHING HSIEH
b. 1950, Nan-chou, Taiwan

Hsieh began creating performance pieces in the late 1970s after finishing three years of compulsory military service in Taiwan. Hsieh performed five One Year Performances between 1978 and 1986 before implementing what he termed his "Thirteen-Year Plan" (1986–99), during which he made art without showing it publicly. Hsieh's solo exhibitions include

Performance 1: Tehching Hsieh, The Museum of Modern Art, New York City (2009); and *Videos in Progress*, Museum of Art, Rhode Island School of Design, Providence (2006). His work has been in group exhibitions such as *The Talent Show*, Walker Art Center, Minneapolis (2010); *The Third Mind: American Artists Contemplate Asia, 1860–1989*, Solomon R. Guggenheim Museum, New York City (2009); and *History of Disappearance*, BALTIC Centre for Contemporary Art, Gateshead, UK (2005); and he participated in the 10th Liverpool Biennial of Contemporary Art and 8th Gwangju Biennale, South Korea (both 2010). Hsieh lives and works in Brooklyn, NY.

JENNIE C. JONES
b. 1968, Cincinnati

Jones attended the Mason Gross School of the Arts at Rutgers University, NJ, where she received her MFA in 1996. She has completed residencies at La Cité Internationale des Arts, Paris (2002–3); the Lower Manhattan Cultural Council at the World Trade Center, New York City (1999); and the Skowhegan School of Painting and Sculpture, ME (1996). Jones's solo exhibitions include *Jennie C. Jones: Counterpoint*, Yerba Buena Center for the Arts, San Francisco (2011); *Jennie C. Jones: Red, Bird, Blue*, Atlanta Contemporary Art Center (2009); and *Simply Because You're Near Me*, Artists Space, New York City (2006). Group exhibitions include *30 Seconds Off an Inch*, The Studio Museum in Harlem, New York City (2009); and *Black Light White Noise: Sound and Light in Contemporary Art*, Contemporary Arts Museum Houston (2007). Jones lives and works in Brooklyn, NY.

JACOB KIRKEGAARD
b. 1975, Esbjerg, Denmark

Kirkegaard graduated from the Kunsthochschule für Medien Köln in 2006. He has presented his installations, compositions, and performances at exhibitions and festivals worldwide, including Club Transmediale, Berlin; The Museum of Jurassic Technology, Los Angeles; and Museet for Samtidskunst, Roskilde, Denmark. Kirkegaard has released five albums and is a member of the sound art collective freq_out. His solo exhibitions include *Motion . . . Matters*, Helene Nyborg Contemporary, Copenhagen (2009); *Stein*, National Centre for Contemporary Arts, Kaliningrad, Russia (2007); and *Aion*, Museet for Samtidskunst, Roskilde, Denmark (2006). He participated in the Aichi Triennale, Nagoya (2010), and his recent group exhibitions include *Sonic Acts XIII: The Poetics of Space*, Nederlands Instituut voor Mediakunst, Amsterdam (2010); *Sound Escapes*, The Space, London (2009); and *Get Real! Real Time + art*, Nykytaiteen museo Kiasma, Helsinki (2004). Kirkegaard lives and works in Berlin.

YVES KLEIN
b. 1928, Nice, France; d. 1962, Paris

Klein studied at the École Nationale de la Marine Marchande and the École Nationale des Langues Orientales, Paris, from 1942–46. Around this time he began studying Rosicrucianism and practicing judo, earning the rank of fourth degree black belt in 1953. Early exhibitions of his monochromes, which he began painting as early as 1949, include *Yves: Propositions Monochromes*, Galerie Colette Allendy, Paris (1956); *Proposite monocrome: epoca blu*, Galleria Apollinaire, Milan (1957); and *Yves: Propositions Monochromes*, Galerie Iris Clert, Paris (1957). His exhibition *The Void*, in which he exhibited nothing at all in the gallery space, opened at the Galerie Iris Clert, Paris, in 1958. Recent solo exhibitions of Klein's work include *Yves Klein: With the Void, Full Powers*, Hirshhorn Museum and Sculpture Garden, Smithsonian Institution, Washington, DC (2010); *Yves Klein: Die blaue Revolution*, Museum moderner Kunst Stiftung Ludwig Wien (2007); *Yves Klein: Body, Colour, Immateriel*, Centre Georges Pompidou, Musée National d'Art Moderne, Paris (2006); and *Yves Klein*, Schirn Kunsthalle Frankfurt (2004). His work has been in a number of recent group exhibitions such as *Malerei: Prozess und Expansion*, Museum moderner Kunst Stiftung Ludwig Wien (2010); *The Death of the Audience*, Secession, Vienna (2009); *Vides (Voids): A Retrospective*, Centre Georges Pompidou, Musée National d'Art Moderne, Paris (2009); *EXIT: Ausstieg aus dem Bild*, Zentrum für Kunst und Medientechnologie Karlsruhe, Germany (2005); *In Pursuit of the Absolute*, The Menil Collection, Houston (2003); *Bodies*, Moderna Museet, Stockholm (2002); and *Out of Actions: Between Performance and the Object, 1949–1979*, The Geffen Contemporary at the Museum of Contemporary Art, Los Angeles (1998).

RENÉ MAGRITTE
b. 1898, Lessines, Belgium; d. 1967, Brussels

Magritte studied at Académie royale des Beaux-Arts de Bruxelles from 1916–18. He moved to Paris in 1927 and had his first solo exhibition at Galerie le Centaure; his work was introduced to an American audience with a 1936 exhibition in New York City. During his lifetime, a retrospective exhibition was mounted at The Museum of Modern Art, New York City (1965). Recent solo exhibitions of Magritte's work include *René Magritte: The Pleasure Principle*, Tate Liverpool (2011); *René Magritte*, Seoul Museum of Art (2006); and *René Magritte*, State Hermitage Museum, St. Petersburg (1998). Recent group exhibitions include *Crime and Punishment*, Musée d'Orsay, Paris (2010); *Galaxy: A Hundred or So Stars Visible to the Naked Eye*, University of California, Berkeley Art Museum and Pacific Film Archive (2009); *Invisible Rays: The Surrealism Legacy*, The Rose Art Museum, Brandeis University, Waltham, MA (2008); *Magritte and*

Contemporary Art: The Treachery of Images, Los Angeles County Museum of Art (2006); *Big Bang au Musée national d'art moderne: Destruction et création dans l'art du XXe siècle*, Centre Georges Pompidou, Musée National d'Art Moderne, Paris (2005); *Surrealism: Desire Unbound*, Tate Modern, London (2001); and a retrospective at The Metropolitan Museum of Art, New York City (1992).

MARK MANDERS
b. 1968, Volkel, The Netherlands

Manders attended the School of Graphic Design in Arnhem, The Netherlands, and the Arnhem Academy of Art and Design. Manders was recently awarded the Dr. A. H. Heineken Prize for Art (2010) and was a recipient of the Philip Morris Art Prize (2002). His solo exhibitions include *Mark Manders: Parallel Occurrences/ Documented Assignments*, The Hammer Museum, University of California, Los Angeles (2010); *Short Sad Thoughts*, BALTIC Centre for Contemporary Art, Gateshead, UK (2006); *The Absence of Mark Manders* (MATRIX 214), University of California, Berkeley Art Museum and Pacific Film Archive (2005); *Isolated Rooms*, The Renaissance Society at The University of Chicago (2003); and *Silent Factory*, Pinakothek der Moderne, Munich (2003). Manders participated in the 55th Carnegie International, Pittsburgh (2008); Documenta 11, Kassel, Germany (2002); and the 24th Bienal de São Paulo (1998). His group exhibitions include *Thrice Upon a Time*, Magasin 3 Stockholm Konsthall (2010); and *Trials and Terrors*, Museum of Contemporary Art Chicago (2005). Manders lives and works in Ronse, Belgium.

CHRISTIAN MARCLAY
b. 1955, San Rafael, CA

Marclay studied at the Ecole Supérieure d'Art Visuel, Geneva, from 1975–77 before earning his BFA in sculpture at the Massachusetts College of Art and Design in Boston. He was also a visiting scholar at Cooper Union, New York City, in 1978. Marclay's recent project *The Clock* has been exhibited internationally at venues such as the 54th Venice Biennale; The Israel Museum, Jerusalem; Los Angeles County Museum of Art; and White Cube, London (all 2011). Other recent solo exhibitions include *Christian Marclay: Festival*, Whitney Museum of American Art, New York City (2010); *Christian Marclay: 2822 Records (PS1), 1987–2009*, P.S.1 Contemporary Art Center, Long Island City, NY (2009); *The Bell and the Glass*, Moderna Museet, Stockholm (2006); *Shake Rattle and Roll: Christian Marclay*, Walker Art Center, Minneapolis (2004); and *Christian Marclay*, Seattle Art Museum (2004). Marclay has participated in such group exhibitions as *Blink! Light, Sound & the Moving Image*, Denver Art Museum (2011); *Alpha Omega: Works from the Dakis Joannou Collection*, DESTE Foundation, Centre for Contemporary Art, Athens (2010); *Haunted: Contemporary Photography/Video/*

Performance, Solomon R. Guggenheim Museum, New York City (2010); *Talking Pictures*, SITE Santa Fe, NM (2009); *Out of Time: A Contemporary View*, The Museum of Modern Art, New York City (2006); and *Playlist*, Palais de Tokyo, Paris (2004). Marclay lives and works in New York City.

ROBERT MORRIS
b. 1931, Kansas City, MO

Morris studied at the University of Kansas and the Kansas City Art Institute from 1948–50 and at Reed College in Portland, OR, from 1953–55. He moved to New York City in 1960 and received his MA from Hunter College in 1966. Morris's solo exhibitions include *Robert Morris: White Nights*, Musée d'art contemporain de Lyon, France (2000); *Robert Morris: The Mind/Body Problem*, Solomon R. Guggenheim Museum, New York City (1994); and *Inability to Endure or Deny the World: Representation and Text in the Work of Robert Morris*, Corcoran Gallery of Art, Washington, DC (1990). His early Minimalist sculptures were included in *Primary Structures*, The Jewish Museum, New York City (1966); and in an exhibition at the Green Gallery, New York City (1963). More recent group exhibitions include *I Am Still Alive: Politics and Everyday Life in Contemporary Drawing*, The Museum of Modern Art, New York City (2011); *In-between Minimalisms*, Van Abbemuseum, Eindhoven, The Netherlands (2010); *Chance Aesthetics*, Kemper Art Museum, St. Louis (2009); *Archive Fever: Uses of the Document in Contemporary Art*, International Center of Photography, New York City (2008); *Full House*, Nykytaiteen museo Kiasma, Helsinki (2008); *Blind at the Museum*, University of California, Berkeley Art Museum and Pacific Film Archive (2005); and *Beyond Geometry: Experiments in Form*, Los Angeles County Museum of Art (2004). Morris lives and works in New York City.

KURT MUELLER
b. 1980, Raritan Township, NJ

Mueller is an artist, critic, and curator. He earned his BA in visual and environmental studies from Harvard University, Cambridge, MA, in 2002 and his MFA from The University of Texas at Austin in 2008. Mueller has completed residencies at Artpace San Antonio (2011); the Core Program of the Glassell School of Art, The Museum of Fine Arts, Houston (2008–10); and the Skowhegan School of Painting and Sculpture, ME (2008). Recent exhibitions of his work include *Living Still*, Artpace San Antonio (2011); *Collection Selections* and *New Art in Austin: 20 to Watch*, Austin Museum of Art, TX (2010, 2008); *Systems of Sustainability: Art, Innovation, Action*, Cynthia Woods Mitchell Center for the Arts and Blaffer Gallery, University of Houston (2009); and *New American Talent: The Twenty-First Exhibition*, Arthouse at the Jones Center, Austin (2006). Mueller lives and works in Los Angeles.

BRUCE NAUMAN
b. 1941, Fort Wayne

Nauman earned his BFA from the University of Wisconsin-Madison in 1964 and his MFA from the University of California, Davis in 1966. He taught at the San Francisco Art Institute from 1966–68 and at the University of California, Irvine in 1970. Nauman has earned numerous awards, including the prestigious Golden Lion for Best National Participation at the 53rd Venice Biennale (2009); the Praemium Imperiale for visual arts, Japan (2004); and the Wolf Foundation Prize in Arts, Herzliya, Israel (1993). He holds honorary doctorates in fine arts from the California Institute of the Arts, Valencia (2000), and the San Francisco Art Institute (1989). Nauman's solo exhibitions include *Bruce Nauman: Days*, The Museum of Modern Art, New York City (2010); *Notations/Bruce Nauman: Giorni*, Philadelphia Museum of Art (2007); *A Rose Has No Teeth: Bruce Nauman in the 1960s*, University of California, Berkeley Art Museum and Pacific Film Archive (2007), which traveled to The Menil Collection, Houston; *Bruce Nauman: Make Me Think Me*, Tate Liverpool (2006); *Elusive Signs: Bruce Nauman Works with Light*, Milwaukee Art Museum (2006); *The Unilever Series: Bruce Nauman, Raw Materials*, Tate Modern, London (2004); and *Bruce Nauman: Mapping the Studio I (Fat Chance John Cage)*, Dia:Chelsea, New York City (2002). He has participated in group exhibitions such as *The Quick and the Dead*, Walker Art Center, Minneapolis (2009); and *Part Object Part Sculpture*, Wexner Center for the Arts, Columbus, OH (2005); as well as the 8th Gwangju Biennale, South Korea (2010); 52nd Venice Biennale (2007); SITE Santa Fe 5th International Biennial, NM (2004); and 47th Corcoran Biennial, Washington, DC (2002). Nauman lives and works in Galisteo, NM.

MAX NEUHAUS
b. 1939, Beaumont, TX; d. 2009, Marina di Maratea, Italy

Neuhaus studied percussion at the Manhattan School of Music, New York City, from 1957–62. In the 1960s, he performed throughout the United States and Europe, including a solo concert at Carnegie Hall in New York City. In 1967 he realized his first electro-acoustic sound installation, *Drive In Music*, in Buffalo. Neuhaus has permanent sound installations in Graz, Austria; Geneva; Turin; New York City; and Kassel, Germany, among many other locations. Neuhaus's solo exhibitions include *Max Neuhaus: Circumscription Drawings*, The Menil Collection, Houston (2008); *Max Neuhaus: Drawings*, P.S.1 Contemporary Art Center, Long Island City, NY (2000); *Max Neuhaus: Evocare l'udibile*, Castello di Rivoli, Museo d'Arte Contemporanea, Turin (1995); and *Projects: Max Neuhaus*, The Museum of Modern Art, New York City (1978). His work has been in such recent group exhibitions as *Proofs and Refutations*, David Zwirner Gallery, New York

City (2011); *Drawn into the World*, Museum of Contemporary Art Chicago (2006); and *Treble*, SculptureCenter, Long Island City, NY (2004). Neuhaus also participated in the 48th Venice Biennale (1999); 2nd Gwangju Biennale, South Korea (1997); and both Documenta 6 and 9, Kassel, Germany (1977, 1992).

AMALIA PICA
b. 1978, Neuquén Capital, Argentina

Pica attended the Instituto Universitario Nacional del Arte and the Instituto Escuela Nacional de Bellas Artes, both in Buenos Aires, from 2003–5, and studied at the Rijksakademie van beeldende kunsten, Amsterdam. She was awarded the illy Prize at Art Rotterdam (2011) and is the recipient of a grant from the Cisneros Fontanals Art Foundation (2011). Pica's solo exhibitions include *Microphones*, *Red Carpet*, De Inkijk, Stichting Kunst en Openbare Ruimte, Amsterdam (2011); *Amalia Pica*, Malmö Konsthall, Sweden (2010); *Robinson Crusoe*, El Centro Cultural Montehermoso, Vitoria-Gasteiz, Spain (2008); and *Amalia Pica: Si no estas tu*, Playstation of Galerie Fons Welters, Amsterdam (2006). Her group exhibitions include *Word Event*, Kunsthalle Basel (2008); *Drawing Typologies*, Stedelijk Museum Amsterdam (2007); and *We all laughed at Christopher Columbus*, Platform Garanti Contemporary Art Center (now SALT), Istanbul (2006). She also participated in the 54th Venice Biennale (2011) and the Aichi Triennale, Nagoya (2010). Pica lives and works in London.

ROBERT RAUSCHENBERG
b. 1925, Port Arthur, TX; d. 2008, Captiva Island, Florida

Rauschenberg briefly studied pharmacology at The University of Texas at Austin before enrolling in the Kansas City Art Institute. He continued his study of art at Académie Julian, Paris, and Black Mountain College, NC. Among the many honors Rauschenberg received are the Medal Award, School of the Museum of Fine Arts, Boston (2002); Lifetime Achievement in Contemporary Sculpture Award, International Sculpture Center, Washington, DC (1996); United States National Medal of Arts Award (1993); and Grand Prize at the 32nd Venice Biennale (1964). Rauschenberg's first solo exhibition was held at the Betty Parsons Gallery, New York City, in 1951. Recent solo exhibitions of Rauschenberg's work include *Signs of the Times: Robert Rauschenberg's America*, Madison Museum of Contemporary Art, Wisconsin (2009); *Robert Rauschenberg: Gluts*, Peggy Guggenheim Collection, Venice (2009); *Let the World In*, National Gallery of Art, Washington, DC (2007); *Robert Rauschenberg: Cardboards and Related Pieces*, The Menil Collection, Houston (2007); and *Robert Rauschenberg: Combines*, The Metropolitan Museum of Art, New York City (2005). Among his many group exhibitions are

the recent *Atlas: How to Carry the World on One's Back?*, Zentrum für Kunst und Medientechnologie Karlsruhe, Germany (2011); *On Line: Drawing through the Twentieth Century*, The Museum of Modern Art, New York City (2010); *Painting, Process and Expansion*, Museum moderner Kunst Stiftung Ludwig Wien (2010); *1969*, P.S.1 Contemporary Art Center, Long Island City, New York (2009); *Die Kunst ist super!*, Hamburger Bahnhof, Museum für Gegenwart, Berlin (2009); *The Art of Participation: 1950 to Now*, San Francisco Museum of Modern Art (2008); *Beauty and the Blonde: An Exploration of American Art and Popular Culture*, Kemper Art Museum, St. Louis (2007); *Speaking with Hands*, Museum Folkwang, Essen, Germany (2006); and the 50th Venice Biennale (2003).

AD REINHARDT
b. 1913, Buffalo; d. 1967, New York City

Reinhardt studied art history with Meyer Schapiro at Columbia University, New York City, from 1931–35 before going on to study painting at the National Academy of Design in 1936 and The American Artists School from 1936–37, both in New York City. After working for the Works Progress Administration's Federal Art Project from 1936–41, he returned to school, studying at New York University's Institute of Fine Arts from 1946–51. Reinhardt taught at Brooklyn College from 1947–67 and lectured at several other colleges and universities during those years. Reinhardt's first solo exhibition was at Columbia's Teachers College (1943), and he showed regularly at the Betty Parsons Gallery, New York City, from 1946 and until his death. Solo exhibitions include *Ad Reinhardt: A Retrospective of Comics*, Institute of Contemporary Arts, London (2011); *Ad Reinhardt: Last Paintings*, Josef Albers Museum, Bottrop, Germany (2010); *Imageless: The Scientific Study and Experimental Treatment of an Ad Reinhardt Black Painting* and *Ad Reinhardt and Color*, Solomon R. Guggenheim Museum, New York City (2008, 1980); and *Ad Reinhardt*, The Museum of Modern Art, New York City (1991). Reinhardt's work has been in recent group exhibitions such as *The Language of Less (Then)*, Museum of Contemporary Art Chicago (2011); *Abstract Expressionist New York*, The Museum of Modern Art, New York City (2010); *just what is it . . .*, Zentrum für Kunst und Medientechnologie Karlsruhe, Germany (2009); *Action/Abstraction: Pollock, de Kooning, and American Art, 1940–1976*, The Jewish Museum, New York City (2008); *The Shapes of Space*, Solomon R. Guggenheim Museum, New York City (2007); *Dark Matter*, White Cube, London (2006); *Big Bang au Musée national d'art moderne: Destruction et création dans l'art du XXe siècle*, Centre Georges Pompidou, Musée National d'Art Moderne, Paris (2005); and *Beyond Geometry: Experiments in Form 1940s–70s*, Los Angeles County Museum of Art (2004).

STEVE RODEN
b. 1964, Los Angeles

Roden earned a BFA from the Otis Art Institute of Parsons School of Design (now the Otis College of Art and Design), Los Angeles, in 1986 and a MFA from the Art Center College of Design, Pasadena, CA, in 1989. Recent solo exhibitions include *Stone's Throw*, Susanne Vielmetter Los Angeles Projects (2011); *Steve Roden: In Between, a 20-Year Survey*, Armory Center for the Arts, Pasadena, CA (2010); *Blinking Lights at Night*, Phonebox, IMO Projects, Copenhagen (2010); *Steve Roden: day ring, night ring*, Henry Art Gallery, Seattle (2006); and *Transmissions from Space*, Fresno Metropolitan Museum of Art and Science, CA (2005). He has participated in such group exhibitions as *Time Again*, SculptureCenter, Long Island City, NY (2011); *ARTe SONoro*, La Casa Encendida, Madrid (2010); *Heart in Heart*, National Museum of Contemporary Art, Athens (2009); *Perspectives 163: Every Sound You Can Imagine*, Contemporary Arts Museum Houston (2008); and *Between Thought and Sound: Graphic Notation in Contemporary Music*, The Kitchen, New York City (2007). Roden's work was included in the 6th Mercosul Biennial, Porto Alegre, Brazil, and he has performed and screened works in places such as the International Film Festival Rotterdam; The Hammer Museum, University of California, Los Angeles; Walker Art Center, Minneapolis; Hamburger Bahnhof, Museum für Gegenwart, Berlin; and the Los Angeles County Museum of Art. Roden lives and works in Pasadena, CA.

DORIS SALCEDO
b. 1958, Bogotá

Salcedo received a BFA from the Universidad de Bogotá Jorge Tadeo Lozano in 1980 and a MA in sculpture from New York University, New York City, in 1984. She has been awarded the Premio Velázquez de las Artes Plásticas from the Spanish Ministry of Culture (2010); the Ordway Prize from the Penny McCall Foundation (2005); and a John Simon Guggenheim Memorial Foundation Fellowship (1995). Salcedo's solo exhibitions include *Plegaria Muda*, Moderna Museet Malmö, Sweden (2011); *The Unilever Series: Doris Salcedo, Shibboleth*, Tate Modern, London (2007); *Neither*, White Cube, London (2004); and *Doris Salcedo/Unland*, New Museum of Contemporary Art, New York City (1998). Among the recent group exhibitions of her work are *Ordinary Madness*, Carnegie Museum of Art, Pittsburgh (2010); *Contemplating the Void*, Solomon R. Guggenheim Museum, New York City (2010); *NeoHooDoo: Art for a Forgotten Faith*, The Menil Collection, Houston (2008); and *The Hours: Visual Art of Contemporary Latin America*, Museum of Contemporary Art, Sydney (2007). She also participated in the 1st Turin Triennale (2005); the 8th International Istanbul Biennial (2003); and Documenta 11, Kassel, Germany (2002). Salcedo lives and works in Bogotá.

TINO SEHGAL
b. 1976, London

Sehgal studied political economy and dance at Humboldt-Universität zu Berlin and Folkwang Universität der Künst, Essen, Germany. His solo exhibitions include *Tino Sehgal à l'Aubette 1928*, Musée d'Art moderne et contemporain de Strasbourg, France (2010); *Tino Sehgal*, Magasin 3 Stockholm Konsthall (2008); *Tino Sehgal*, Walker Art Center, Minneapolis (2007); and *Swing Space: Tino Sehgal*, Art Gallery of Ontario, Toronto (2006). His work has been in group exhibitions such as *After Nature*, New Museum of Contemporary Art, New York City (2008); *The World As a Stage*, Tate Modern, London (2007); and *Tomorrow*, Kumho Museum of Art, Seoul (2007). He participated in the Göteborg International Biennial for Contemporary Art, Sweden (2011); 8th Gwangju Biennale, South Korea (2010); and 51st Venice Biennale (2005). Sehgal lives and works in Berlin.

STEPHEN VITIELLO
b. 1964, New York City

Vitiello earned his BA from Purchase College, New York. His recent solo exhibitions include *More Songs About Buildings and Bells*, Museum 52, New York City (2011); *A Bell for Every Minute*, The High Line, New York City (2010); and *Stephen Vitiello*, The Project, New York City (2006). Vitiello also recently created a permanent sound installation for the Massachusetts Museum of Contemporary Art, North Adams, and he took over the *Village Voice* website as part of Neterotopia in 2006. His work has been in group exhibitions such as *September 11*, MoMA PS1, Long Island City, NY (2011), and he participated in the 15th Biennale of Sydney (2006) and the 2002 Whitney Biennial, New York City. Vitiello has performed at the Tate Modern, London; the San Francisco Electronic Music Festival; The Kitchen, New York City; and the Fondation Cartier, Paris. Vitiello lives and works in Richmond, Virginia, where he is Associate Professor of Kinetic Imaging at Virginia Commonwealth University.

ANDY WARHOL
b. 1928, Pittsburgh; d. 1987, New York City

After graduating from the School of Fine Arts at the Carnegie Institute of Technology (now Carnegie Mellon University), Pittsburgh, in 1949, Warhol moved to New York City. He began a career in illustration and advertising, designing window displays for Bonwit Teller department stores and the I. Miller shoe company, but turned to painting and drawing in the 1950s. His first solo exhibition was at the Hugo Gallery, New York City, in 1952, and he opened his famed studio, The Factory, ten years later. Warhol has had numerous solo exhibitions, among them the recent *Warhol: Headlines*, National Gallery of Art, Washington, DC (2011); *Andy Warhol: Motion Pictures*, The Museum of Modern Art, New York City (2010); *Andy Warhol: The Last Decade*, Milwaukee Art Museum (2009); *Celebrities: Andy Warhol and the Stars*, Hamburger Bahnhof, Museum für Gegenwart, Berlin (2008); *Andy Warhol: Other Voices, Other Rooms*, Stedelijk Museum Amsterdam (2007); *Andy Warhol/Supernova: Stars, Deaths, and Disasters, 1962–1964*, Walker Art Center, Minneapolis (2005); and *Andy Warhol: Screen Tests*, Wexner Center for the Arts, Columbus, OH (2003). Recent group exhibitions of his work include *The Talent Show*, Walker Art Center, Minneapolis (2010); *Still/Moving*, The Israel Museum, Jerusalem (2010); *Pop Life: Art in a Material World*, Tate Modern, London (2009); *The Art of Participation: 1950 to Now*, San Francisco Museum of Modern Art (2008); *Beauty and the Blonde: An Exploration of American Art and Popular Culture*, Kemper Art Museum, St. Louis (2007); and *Into Me/Out of Me*, P.S.1 Contemporary Art Center, Long Island City, NY (2006).

MARTIN WONG
b. 1946, Portland, OR; d. 1999, San Francisco

Wong studied ceramics at Humboldt State University, CA, graduating in 1968. Ten years later, he moved to New York City and began to work primarily with paint. Solo exhibitions of Wong's work include *Martin Wong: Works 1980–1998*, Galerie Buchholz, Cologne (2010); *Martin Wong: Everything Must Go*, P.P.O.W. Gallery, New York City (2009); *Martin Wong's Utopia: Taiping tien quo (A Peaceful Life and Heavenly Place)*, Chinese Historical Society of America Museum and Learning Center, San Francisco (2004); and *Sweet Oblivion: The Urban Landscape of Martin Wong*, New Museum of Contemporary Art, New York City (1998). Select group exhibitions include *Art, Access & Decay: NY 1975–1985*, Subliminal Projects Gallery, Los Angeles (2011); *Strange Comfort (Afforded by the Profession)*, Kunsthalle Basel (2010); *Urban Archives: Happy Together*, Bronx Museum of the Arts, NY (2010); *Asian/American/Modern Art: Shifting Currents, 1900–1970*, de Young Museum, Fine Arts Museums of San Francisco (2008); *Big City Fall: Oiwa, Schneemann, Wojnarowicz, Wong*, P.P.O.W. Gallery, New York City (2006); and *Pollock to Today: Highlights from the Permanent Collection*, Whitney Museum of American Art, New York City (2001).

CREDITS

Produced by the Publications Department of the Menil Collection: Joseph N. Newland, Director of Publishing, and Sarah E. Robinson, Assistant Editor
Editors: Joseph N. Newland with Sarah E. Robinson
Rights and Reproductions Manager: Er-Chun Amy Chien
Graphic Designer: Rita Jules, Miko McGinty Inc.
Typeface: Fakt
Paper: Scheufelen Phoenix Motion Xenon
Reproductions: Prographics Inc., Rockford, Illinois
Printing and binding: Conti Tipocolor S.p.A., Florence, Italy

Library of Congress Cataloging-in-Publication Data

Kamps, Toby.
 Silence / Toby Kamps, Steve Seid ; with a contribution by Jenni Sorkin. — First [edition].
 pages cm
 Summary: "Explores silence in 20th and 21st century art and films, including works by Joseph Beuys, Maya Deren, Christian Marclay, Bruce Nauman, Robert Rauschenberg, and Doris Salcedo"—Provided by publisher.
 Published in conjunction with the exhibition Silence. Organized by The Menil Collection, Houston, and the University of California, Berkeley Art Museum and Pacific Film Archive.
 Includes bibliographical references.
 ISBN 978-0-300-17964-4 (hardback)
 1. Silence in art—Exhibitions. 2. Art, Modern—20th century—Exhibitions. 3. Art, Modern—21st century—Exhibitions. 4. Experimental films—Exhibitions. I. Seid, Steve. II. Sorkin, Jenni. III. Menil Collection (Houston, Tex.) IV. Berkeley Art Museum and Pacific Film Archive. V. Title.
 NX650.S56K36 2012
 709.04'00747641411—dc23
 2012018430